Canon EOS Digital Cameras

Erik Sherman

ALPHA

A member of Penuin Group (USA) Inc.

To my parents, who forgot to tell me what I'd never be able to do.

ALPHA BOOKS

Published by the Penguin Group

Penguin Group (USA) Inc., 375 Hudson Street, New York, New York 10014, U.S.A.

Penguin Group (Canada), 10 Alcorn Avenue, Toronto, Ontario, Canada M4V 3B2 (a division of Pearson Penguin Canada Inc.)

Penguin Books Ltd, 80 Strand, London WC2R 0RL, England

Penguin Ireland, 25 St Stephen's Green, Dublin 2, Ireland (a division of Penguin Books Ltd)

Penguin Group (Australia), 250 Camberwell Road, Camberwell, Victoria 3124, Australia (a division of Pearson Australia Group Pty Ltd)

Penguin Books India Pvt Ltd, 11 Community Centre, Panchsheel Park, New Delhi—110 017, India

Penguin Group (NZ), cnr Airborne and Rosedale Roads, Albany, Auckland 1310, New Zealand (a division of Pearson New Zealand Ltd)

Penguin Books (South Africa) (Pty) Ltd, 24 Sturdee Avenue, Rosebank, Johannesburg 2196, South Africa

Penguin Books Ltd, Registered Offices: 80 Strand, London WC2R 0RL, England

Copyright © 2007 by Erik Sherman

International Standard Book Number: 978-1-59257-615-9

Library of Congress Catalog Card Number: 2006932997

09 08 07 8 7 6 5 4 3 2 1

Interpretation of the printing code: The rightmost number of the first series of numbers is the year of the book's printing; the rightmost number of the second series of numbers is the number of the book's printing. For example, a printing code of 07-1 shows that the first printing occurred in 2007.

Printed in the United States of America

Note: This publication contains the opinions and ideas of its author. It is intended to provide helpful and informative material on the subject matter covered. It is sold with the understanding that the author and publisher are not engaged in rendering professional services in the book. If the reader requires personal assistance or advice, a competent professional should be consulted.

The author and publisher specifically disclaim any responsibility for any liability, loss, or risk, personal or otherwise, which is incurred as a consequence, directly or indirectly, of the use and application of any of the contents of this book.

Most Alpha books are available at special quantity discounts for bulk purchases for sales promotions, premiums, fund-raising, or educational use. Special books, or book excerpts, can also be created to fit specific needs.

For details, write: Special Markets, Alpha Books, 375 Hudson Street, New York, NY 10014.

Publisher: *Marie Butler-Knight*
Editorial Director: *Mike Sanders*
Managing Editor: *Billy Fields*
Acquiring Editor: *Michele Wells*
Development Editor: *Ginny Munroe*
Production Editor: *Megan Douglass*

Copy Editor: *Jennifer Connolly*
Cover Designer: *Bill Thomas*
Book Designer: *Trina Wurst*
Indexer: *Brad Herriman*
Layout: *Ayanna Lacey*
Proofreader: *Aaron Black*

Contents at a Glance

Appendixes

Contents

Introduction

Everyone loves photographs—even people who hate being photographed at least enjoy looking at them. We collect pictures of birthdays and graduations, of days at the beach and nights on the town, of fireworks and fireflies. Photographs have become a way to jog our memories and gain new perspective on our lives and the world. Look at what the greatest photographers, practicing anything from photojournalism to advertising, have been able to say in images.

Two things separate the pros from the initiates. One of those is equipment that has the ability to record what you're seeing in your mind's eye. And Canon's EOS digital camera line is a great way to get those capabilities. Even the consumer models can let someone take exciting photos, with the ability to provide automatic operation or to let the person pressing the button take full control. If you're buying Canon equipment, you have overcome the first hurdle.

More difficult, though, is learning to use that equipment. Sure, each camera comes with a manual, but that only tells you how to operate the camera. What you really need is an understanding of what these features actually mean to good photography. In other words, the manual tells you how to use the features; you need to know how to *make use* of them. That's why this book is in your hands.

Instead of being a super manual that walks you through every possible feature and function on the camera, this book focuses on those that are the main concern when you want to take photographs. Yes, it's about EOS cameras, but completely from the view of how you can take better shots with them, connecting the features with a knowledge of photography so when you make choices, your decisions come from what will get you closer to the types of images you admire and the ones you can see in your mind but that in the past haven't quite been able to get into the camera.

You'll start in the first part of the book learning more about the fundamentals of the Canon line and getting nudged to review the features, learn where all the controls are, and understand a bit more about the lenses available.

In the second part we plunge into the basics of taking a good photograph. That includes everything from keeping the camera steady, composing images, and focusing the camera where you want attention to setting the right exposure, reviewing the results, manipulating the image settings, and protecting all those expensive gizmos.

The third part is for more advanced techniques, such as making better use of light in your photography, adapting your technique for specific types of subjects, and using computers and software to change images after you've taken them, like the digital equivalent of a high-end darkroom.

At the end of the book, you'll find a glossary of all the special terms that pop up as well as a set of resources for getting some of the specialty hardware, software, and accessories that can be handy.

But don't expect the book to get overly heavy. Taking photographs should be about having fun, even when you're at your most serious. Fun's what I had writing it, and if you don't have fun in reading and taking your own pictures, I'm going to pout. And that's a pretty ugly image that none of us wants to see.

How to Use This Book

Now why are you asking me how to do this? You've been reading books your entire life—longer than you've been planting your face behind a camera. Okay, I'll tell you, but it's only because of the little old lady in the back with the trembling lower lip—I was always a sucker for that.

First, you need to have your camera manual handy because there are at least half a dozen Canon EOS cameras, and each one does things differently from the others. Because there are so many EOS models, with each handling lots of things its own special way, I can't go through the particulars of how to physically do every little feature—it would take a fourth of the book just to finish getting the batteries into a camera. Well, maybe not a fourth, though it would sure seem like it.

Next, look over **Part 1, "The Canon EOS Line,"** to get a little more familiar with your gear.

Now you'll want to spend some quality time with **Part 2, "The Basics,"** to work on—Who could have expected this?—the basics of taking good shots with your EOS camera. You'll learn fundamental skills like focusing, setting the exposure for your pictures, and even how to hold the camera.

After that, **Part 3, "Advancing Your Technique,"** will help you take greater control over lighting, learn some tricks of getting better pictures in particular circumstances, and tweak your results on a computer so you can wow 'em in Peoria. (You say you haven't been to Peoria? Oh, I *hate* it when my metaphors go nowhere.)

Extras

If you're interested in photography, you are, whether you like it or not, a visual aesthete. (I hope you can have words like that in print. If you see a blank space right before the left parenthesis, you'll know that you can't.) But you're also looking for information.

So we've got a great feature for you: four types of boxed additional information called sidebars. Yes, we're blending useful content with an interesting layout to satisfy you. Yes, we also found it thoughtful. Here are the sidebar types that you'll see:

Photo Pro Jargon

When I have to use photographic argot, I define the words here. And if you lose track or—horrors!—don't read this book cover to cover and memorize every bit of it, you'll find them repeated in the glossary, Appendix A.

Thumbnail Tip

These inside hints will make your photos better, your life easier, and will make sure that you have at least three extra good hair days next month.

News Flash _____

You can learn about something curious or interesting that won't necessarily make any difference to your photography. Oh, go mad and give them a read.

TIFF Luck _____

Sometimes there are bad things out there waiting to mess you up. Here's where I point out the dangerous photo flora and fauna.

Acknowledgments

Thanks to Marilyn Allen, the agent who brought me together with Alpha Books for this project, and to Jennifer Lawler, a client of Marilyn's who kindly remembered that I was a photographer as well as a writer and who recommended me.

Michele Wells at Alpha Books was a delight to work with and was a great help when things got confusing or difficult, as was Billy Fields when love or money or a fast Internet connection couldn't get large image files from here to there. And developmental editor Ginny Munroe actually laughed at some of the jokes, which means she deserves my thanks and that, I guess, I actually have to send her that check now. (I never thought she would.) Megan Douglass herded the project through production, and if it wasn't for her, these would literally be blank pages. Thanks to Jennifer Connolly for the thankless task of editing my copy (and becoming the subject of a paradox). And thanks to Ken Sklute, Canon Explorer of Light, for being the technical editor for this book.

Special thanks to some companies that were helpful in the process in no particular order other than alphabetic: ACD Systems, Adobe Systems, Case Logic, Lexar, Lowepro, Manfrotto, Photographic Solutions, SanDisk, and Wacom. And, of course, without Canon, which makes the Canon EOS cameras, this book would be over, oh, about now. Extra thanks go to Canon's website, with manuals and technical information available for download at any hour that a wayward writer might find himself at work.

I'd also like to thank some willing photo subjects: models and actresses Alexandra McDougall, Christine Voytko, Penny and Alana Benson, and such family and friends as Allie Sherman, Matthew Sherman, and Thomas Guiney.

Finally, my wife, Lisa, and my kids, the aforementioned Allie and Matt, showed enormous patience and understanding when I'd find myself sitting behind the keyboard and delaying things when they had other plans.

Special Thanks to the Technical Reviewers

The Complete Idiot's Guide to Canon EOS Digital Cameras was reviewed by an expert who not only checked its technical accuracy but also added significant insights and suggestions. Our special thanks to Ken Sklute.

Trademarks

All terms mentioned in this book that are known to be or are suspected of being trademarks or service marks have been appropriately capitalized. Alpha Books and Penguin Group (USA) Inc. cannot attest to the accuracy of this information. Use of a term in this book should not be regarded as affecting the validity of any trademark or service mark.

The Canon EOS Line

If you can't tell the players without a program, how are you going to take the picture without the basic EOS guide? In the first three chapters, you'll learn something about the broad line of cameras that make up the Canon EOS family.

You'll get to know more of how the cameras work, understand the different options for operating the units, and see how the lenses fit in—and on. That gives you the grounding you'll need to use the camera, but don't put the manual away, as you'll need some of the model-specific information it contains.

Chapter 1

Canon Shooter

In This Chapter

- ◆ Use features to improve your pictures
- ◆ Learn the big differences among the various EOS camera models
- ◆ Camera-buying tips

Congratulations on purchasing your Canon EOS digital camera! That sounds like something you'd read out of a "how to use this thing" manual. But that's where the resemblance stops, because this book is not some sort of extended manual.

The whole point here is to get beyond a list of functions and mechanical directions. You've just bought (unless you've decided to buy but haven't yet, in which case excuse me for jumping the gun) some great equipment. What you want to do is take great pictures. That's what we'll be doing. Because there are so many EOS models, with each handling lots of things its own special way, I can't go through the particulars of how to work every feature—it would take a fourth of the book just to finish getting the batteries into a camera. Well, maybe not a fourth, though it would sure seem like it.

So don't put that manual in the desk drawer. You'll want the details of how to work the features on your particular camera. In this book, we'll be spending our time learning how to use those features to make you—and your pictures—look good.

Yes, You Done Good

There are several things (other than exercise and eating sensibly) that make the Canon EOS line of *digital SLR* (*DSLR*) bodies so strong:

Photo Pro Jargon

In an **SLR**, or single lens reflex, what you see in the viewfinder is what the camera will record. A moving mirror reflects what comes through the lens up toward your eye. When you push the shutter button, the mirror swings up before the shutter opens. A **digital SLR**, or **DSLR**, captures the image electronically.

News Flash

Having that backward compatibility—offers one huge advantage: if you own an older EOS film camera, your older lenses will still work with the new digital body, so you don't need all new ones.

- After decades of making top quality film, Canon knows how to make an *SLR* work.

- Automatic focusing and exposure control are fast, flexible, and clever tools that help you concentrate on taking pictures, not on technicalities. And they're not even smug about it.

- With advanced imaging controls, you adjust characteristics of your pictures so they come out the way you want.

- You want accessories? There are tons of available accessories. Some of the DSLRs work with new specialty EOS digital lenses (see Chapter 3 for details on which work with what).

The trick with all these capabilities is not just to know how to make them work, but how to use them to get the pictures you want. That's why, instead of concentrating on operational pecadillos, we

look at the major features of the cameras and lenses and how you can get them to work better for you. So keep your camera manual handy, because you will need details on how to do such things as configure the auto focus and adjust the color of your pictures.

Photo Models

"You're looking marvelous ... turn your head left a bit ... look down ... *fabulous!*"

Oh, sorry—I lost control there, and these models are inanimate objects, after all. But with all they can do, sometimes it seems as though they have a life of their own. Let's snoop and see what that life is like.

First off, we have to sort through the numerous digital EOS models on the market. There are three general lines:

◆ Consumer —Digital Rebel, Digital Rebel XT, Digital Rebel XTi

◆ *Prosumer*—10D, 20D, 30D

◆ Professional—1D, 1D Mark II, 1Ds, 1Ds Mark II, 5D

Photo Pro Jargon

Prosumer is a line of cameras with more capabilities than a consumer model, but still shy of the features (and price) of a pro camera.

JPEG and **RAW** are image file formats for how the camera records pictures. JPEGs are smaller, but are lower quality. See Chapter 9 for more information about these.

EF-S refers to the lens line designed specifically for the digital cameras; the **EF** lenses work with all the digital DSLRs as well as with the older film SLRs.

The following table gives a surface look at the differences among these cameras.

Some EOS Camera Models

Model	Megapixels	Frames per second	Maximum Burst per Compatible second	EF-S
Digital Rebel	6.5	2.5	4	Yes
Digital Rebel XT	8.0	3	14*	Yes
Digital Rebel XTi	10.1	3	27*	Yes
10D	6.3	3	9	No
20D	8.25	5	6	Yes
30D	8.2	5	11	Yes
1D	4.15	3 or 8	16	No
1D Mark II N	8.2	3 or 8.5	22	No
1Ds	11.1	3	10	No
1Ds Mark II	16.7	4	11	No
5D	12.8	3	17	No

Calculated for Large Fine JPEG instead of RAW as for the other models.

Some of the cameras in the above table are obsolete and have moved on into memory and off Canon's list of advertised products. But don't let that bother you. Just like all the other camera companies, Canon whips through new models. That's ok, because the older ones last a long time. In fact, I still shoot with a 10D, which, at this point, is two models back in the prosumer line.

Whether the latest version or not, in general if you're taking photos for your own pleasure, a consumer model will give you all you need. If you're an advanced photographer and are willing to pay significantly more for some additional features and capabilities—like faster shutter speeds or higher ISO speed ratings (see Chapter 7 for more information on these), go for the prosumer. There's little to no reason for you to spend the kind of money (as in very expensive) it takes to get a professional model. That's why I'm going to focus on the consumer and prosumer lines.

Notice that the cameras have some pretty big differences. Believe it or not, that's just the beginning. If I strung together all of the potential variations in exactly what these cameras do and specifically how you work them, I'd end up with something longer than a grocery list for a large family reunion.

Make the Purchase Plunge

All these differences—and the features—are pretty theoretical until you actually start working with a camera, and to do that you'll have to buy it. (Even if you have, stick around for a minute, because there are some good things to know for the future.)

You can pick up a camera at a number of places: specialty camera stores, discount retailers, or online, to name a few.

Buy just the body (a good choice if you have Canon EOS film equipment already), or look for one of the packages where you get a lens or two as well as other accessories. Check carefully, particularly with mail order and Internet dealers, to know exactly what you'll get. Some of these outfits—particularly some of the big mail-order dealers—will start substituting lenses from other vendors. Now, many third-party lenses are good, but on general principle you don't want to do business with someone who could pull a fast one.

Thumbnail Tip

I don't want to scare you off mail-order, because you can get good prices and service. The trick is finding companies that are professional in their dealings. Look for photo discussion groups on the Internet and ask others which companies are on the up-and-up and where the deals are too good to be true. I've personally done business multiple times with both B&H Photo Video and Adorama—they have good reputations and the only time or two I had a problem, it got quickly resolved.

You may find a strong temptation to wait for the next round of nifty feature additions before buying your camera. Here's a suggestion—don't. You will never know what the next version brings, and in the meantime, you're not taking pictures.

TIFF Luck

If you do buy new, particularly if you do through the Web, ask specifically if the product is North American or so-called gray market, which means that it's been brought in from overseas. The gray market products will be cheaper, but they won't have a U.S. warranty. If you run into problems, getting help might require you to undertake a transcontinental vacation. It's great to have the excuse to travel, but paying the extra for products with U.S. warranties is cheaper than hotel and airfare. On the serious side again, if you are told that something has a U.S. warranty and it doesn't, return it and do business with another company.

Then again, you could just pick up someone else's equipment—and, no, I don't mean that you should become Light-Fingered Louie—we're talking the used market here. Buying used can be a great way to get good equipment at a decent price. I've often paid for new bodies and added second-hand lenses that let me get a lot more for my money.

Here is a list of the places I would recommend buying used cameras and equipment from:

◆ **eBay**: You have to be careful and check people's ratings carefully, as there are some lowlifes. Also, don't get caught up in the flurry of wanting to *win* that online auction because the prices can run so high in some cases that you could literally buy new for less. Still, there are good buys to be had at times.

◆ **Internet classifieds**: People around the country are often selling equipment that they no longer want for many reasons—like they need the money to buy a new toy. Check a book on how to buy and sell on the Internet and look up escrow services. It makes things cost a bit more, but it's a great way to make sure that you get what the seller advertised.

◆ **Local classifieds**: Whether you go to the newspaper or one of these specialty publications that are nothing but ads, you can not only find something but probably see it before you buy.

◆ **Swap meets**: All around the country, photo clubs, and enthusiasts hold photo flea markets. You can never tell when you'll find a pleasant surprise.

 Thumbnail Tip _____

If you decide to save money and buy someone's used camera, you might find that the manual doesn't make it with the camera body. Not to fret: go to Canon's website—www.usa.canon.com—and head to the product information. Look up your camera model, check downloads or support, and you'll be able to get a whole new manual, albeit in electronic form. But think of it this way: you won't be able to get a food stain from lunch on it. No, all that will fall on your keyboard.

The Least You Need to Know

◆ Features of your EOS camera will help you take better pictures, after you learn how to use them smartly. (And putting the features into the service of better pictures is what the rest of this book is for.)

◆ Consumer models can give you the same key features of the more expensive versions.

◆ You can use older EOS lenses with the new digital cameras.

◆ When buying new, be careful of gray-market products that don't have a U.S. warranty.

◆ Used gear lets you get a lot more for your money.

Chapter 2

Control Freak

In This Chapter

- ◆ How imaging works in the camera
- ◆ Different EOS models
- ◆ Choosing operating modes

The term *control freak* has its negative connotations, but for now we're officially going to ignore 'em. To paraphrase the film *Wall Street*, control is good. If you can't control how the picture comes out so it looks the way you wanted it to, you're wasting your time and the camera's battery charge.

Although point-and-shoot cameras are happy to make all the decisions, you've obviously decided on something more sophisticated. That was a smart decision, because the lower-end cameras will be fine in normal conditions, but make the conditions challenging and you're dependent on a fickle Lady Luck. Gordon Gekko wouldn't approve.

With an EOS camera, you've got flexibility. You can be the one in control, you can let the camera handle what it needs to do, or the two of you can even split the responsibility. In Part 2, we spend more time on negotiating who's in charge of holding the

camera, framing a shot, focusing, setting the exposure, and snapping the picture. But it probably makes more sense to first get an overview of what's involved with operating the camera, even if it is an exercise in mass procrastination and we postpone the nitty-gritty. The first step in control is knowing how something works.

The Magical Light Machine

It's really kind of amazing—light goes in through the lens and electrical charges come out onto the *CF card* as images. But there's a lot more than a set of tiny pipes running from the lens to the storage, as Figure 2.1 intimates.

Photo Pro Jargon _____

A **CF card** is a compact flash card—a type of storage that you put into the camera to keep your pictures until you move them to your computer. A **digital signal processor (DSP)** is a computer chip that manipulates information, such as an image file.

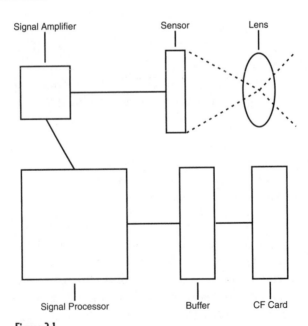

Figure 2.1

The light goes in and it goes round and round and comes out there.

This is a simplified picture, but it gives you an idea of what happens:

1. Light enters the lens and strikes the image sensor.

2. The sensor converts the light into tiny electrical signals that get neatly shuttled out.

3. Those newly minted but miniscule electrical signals go into an amplifier that makes them larger.

4. A *digital signal processor* (*DSP*) does all kinds of mathematical calculations that take those signals and turn them into something that will become a digital image. (See Chapter 9 for more on this topic.)

News Flash

The DSP takes the image data from the sensor and does all kinds of manipulations to get a picture that looks like what you expect. But you can also save the images as they come off the sensor, transfer them to your computer, and see the results as the manipulations happen.

To get the picture the way you want it, though, someone—or something—needs to make decisions, such as …

◆ The amount of light to let in (Chapter 7)

◆ How fast the shutter should move and how wide the lens opening should be (Chapter 7)

◆ Focusing (Chapter 6)

◆ The characteristics of the image file (Chapter 9)

◆ Adjusting colors (even more Chapter 9)

◆ When to press the button (Chapter 8)

◆ Whether to change the lens settings for a different effect (Chapter 6)

As I mentioned earlier, all the decisions above must be made when you take a picture. And as you might have guessed from the beginning of this chapter, there's some split between what you and the camera will decide. Some of the things that the camera can do even depend on how you want it to do them.

TIFF Luck _____

Here's where you should pull out your camera manual. Although the operating principles of all the EOS cameras are similar, the specifics make all the difference. I know that you don't want to read manuals. *I* don't like reading manuals, and I used to write them many years ago. So don't do a cover to cover perusal, but do read the first chapter to see the layout and know where all the switches and buttons are.

Operator, Can You Help Me Take This Shot?

What referees the division of labor between you and the camera is the camera's *operating mode*. There are all kinds of controls on the camera body and a range of others that come up on menus on the LCD screen on the back. But for now you just need to look at the *mode dial*.

You'll notice on it all sorts of little graphics and what appear to be obscure abbreviations. That's exactly what they are, though the obscurity is about to drop away. Each one is an operating mode that controls how the camera takes a picture, and you'll find these on virtually all of the EOS DSLRs. Canon groups them into two categories: *basic zone* and *creative zone*. Roughly speaking, basic zone means automated and creative zone means you've got at least some work cut out for you.

Photo Pro Jargon _____

The **operating mode** is the camera setting that determines what assumptions the camera makes about how you will use it. The camera's **mode dial** sets the operating mode. Actually, *you* set the mode. I mean, the cameras are advanced, but it's not like a hand comes out and does the turning for you. (That's for the next generation.) **Basic zone** operating modes are the automated ones; the **creative zone** modes are those that require you to make your own adjustments.

It's hard to keep them straight at first, so let's have a preview. The basic zone modes make lots of assumptions about what you're trying to shoot and how. The creative zone modes give you lots of choices, but usually

make a basic assumption. Here's a table that will let you start matching the modes to what the camera expects that you are doing.

Mode	Graphic or Abbreviation	What it Assumes
Automatic	Rectangle	You're not doing much of anything.
Portrait	Little Head	You're taking a picture of someone and you want a blurred background, taking shots one at a time.
Landscape	Mountains	Taking shots one at a time, you want a clear view from there to eternity, otherwise known as whatever is in the distance.
Close-up	Flower	Taking one shot at a time, you want to get close to things like flowers and bees to take their pictures. (Bees? Well, maybe not *that* close.)
Sports	Running	You want to take in rapid succession shots of people playing some sport or other.
Night Portrait	Person and Star	You'll take flash pictures at night of someone, one picture at a time.
Flash Off	Line Through Lightening Bolt	You'll take pictures one at time without a flash.
Program AE	P	Like Auto, but can change a lot of the particulars of how the camera works.

continues

continued

Mode	Graphic or Abbreviation	What it Assumes
Shutter-Priority	Tv	You set the *shutter speed* and the camera sets the aperture to match. (Tv stands for Time value.)
Aperture and Priority	Av	You set the *aperture*, the camera sets the shutter speed. (Canon says that Av stands for aperture. I'm still trying to find the v in the word.)
Manual	M	The gloves come off and you're responsible for everything.
Automatic Depth of Field	A-DEP	You want to get as much of the picture in focus as possible.

Photo Pro Jargon

The **shutter speed** is how long the camera opens the shutter to expose the sensor to light from the lens. **Aperture** is a changeable opening inside the lens that determines how much light can enter.

This may seem like a lot, but if you want to see a lot of detail, look at Chapters 6 through 9.

Right now it's time to play.

Take your camera and try out all the different controls. Don't worry about breaking something because you can always return all the settings back to their normal values.

After you've gotten bored with the glorious experience of navigating

through menus and watching displays change on LCD screens, start experimenting with the basic zone modes. To do that, use the manual's directions to find the shutter button and have at it. Try the operating modes the way they're supposed to be used, or switch things around and use them differently. Don't worry, I won't tell.

The Least You Need to Know

◆ Different operating modes either automatically optimize how the camera works for different types of pictures or give you choices of how you'll take control of the camera's operations.

◆ Some operating modes are fully automatic, although others let you take control.

◆ You'll be able to repeat what the digital signal processor does on your computer.

3

Them There Eyes

In This Chapter

- ◆ The parts of a lens
- ◆ Lenses by the numbers
- ◆ Choosing a lens
- ◆ Mounting a lens
- ◆ Using filters

Hey, get me my glasses, would you? No, not those distance glasses. No, not those either—they're the reading glasses. Not the bifocals, not the ... you get the idea.

People use different types of glasses under different situations because each helps focus images differently onto the eye's retina. Your EOS camera is exactly the same. Every time you want to take a picture of something, you need a lens to focus the image onto the camera's sensor. (See Chapter 2 for a diagram of how the lens and sensor work together.) By choosing a different lens, you change the way the image forms.

Take a look at the list of lenses available for the EOS line, and you'll see dozens of choices, all specified by numbers of various sorts. Then there are all the lenses from other manufacturers

that *also* work with Canon cameras. You've got to learn what you need and when. But how? Glad you asked.

Parting with That Lens

Lenses are amazing devices. Pieces of glass, ground to an annoying degree of exactness exceeded only by a difficult boss or parent, which see the world and bring it to the camera's imaging sensor. But there's more to lenses than just that, as you can see in the admittedly abstract example in Figure 3.1.

Figure 3.1

The basic parts of the basic lens.

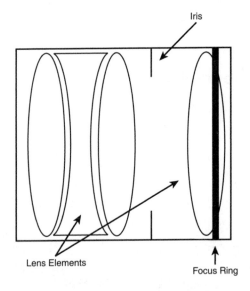

Iris

Lens Elements

Focus Ring

Photo Pro Jargon _____

The **lens elements** are the pieces of glass that provide that optical je ne sais quoi. The **iris** expands or contracts on command to limit the amount of light passing through the lens and reaching the imaging sensor. **Aperture** is how wide the lens iris is open and how much light can get in. The **focusing ring** is the part of the lens you turn back and forth to focus the image.

There are the *lens elements*, the *iris*, and the *focusing ring*. Here's what they do:

- The lens elements perform all the heavy optical lifting, gathering light on one end and focusing the resulting image onto the sensor at the other.

- The iris is this ingenious set of overlapping metal blades that create the *aperture*—the changeable opening that controls how much light can get to the sensor. That'll be important later on, as you'll see when reading about exposure in Chapter 7.

- The focusing ring lets you adjust the spacing among the lens elements, letting you get a focused image instead of a mass of abstract blur. More on focusing images and using the focusing ring in Chapter 6.

There are some things the figure doesn't show you, such as all the electronics and the small motors that let the camera control the lens focus and the iris opening. Also, there's a small switch that lets you decide whether you focus yourself or graciously allow the camera to do it—and that's all in Chapter 6, as well.

There are more things to say about lenses, and before we can go into the different types available to you, let's do some numbers! (I appreciate that many of you reading this may not be excited by the prospect, but please humor me—at least through the next section.)

Counting on Your Lens

Choosing the right lens can do incredible things for your pictures; it can bring things closer or stretch out how much you can fit into one photograph. But if you walk into a store looking for the right lens, you're going to sound peculiar if you ask, "I'd like one of those stretchy-out lenses, please."

When it comes to lenses, everything comes down to numbers. Happily, there are only a few that are important to remember:

- *Focal length*
- *f-stop*
- *Lens speed*

Photo Pro Jargon _____

A lens's **focal length** is the distance from the lens to where its image forms when the object being viewed is in focus when at "infinity"—which, for all practical purposes, means a stone's throw away. **F-stops** are a shorthand for specifying and setting the size of the aperture; the smaller the f-stop, the bigger the aperture and, thus, more light can enter. **Lens speed** is the largest amount of light the lens can let in and is the same as the lens's lowest f-stop.

The units attached to the numbers may sound odd. These days, focal lengths are always specified in millimeters—welcome to the metric world. Don't worry, you won't actually have to convert anything. As for f-stops, they have a meaning all their own and Chapter 7 should make all that clear.

That wasn't so bad, was it? It doesn't seem like much information, but by the time the manufacturers are done, that can turn into a whole lot of lenses, as you can see in Figure 3.2.

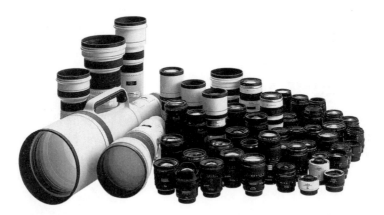

Figure 3.2

Here they are, some telephotos so big they have built-in handles.

Yup, that's a big number of lenses. And the next section explains how to tell the difference from one to the next, letting you impress friends and relatives with the breadth of your photographic education.

Pick a Lens, (Almost) Any Lens

Feeling confined by our previously monolithic discussion, let's break things out by the numbers. There are three general categories of lenses based on their focal lengths, as the table shows.

Lens Categories

Type	Focal Length	Effect Range (in mm)
Normal	50	Things look pretty much as your eye might expect.
Wide-Angle	14–35	Acts as though you stepped back from your subject, making everything look smaller and farther away.
Telephoto	85–400+	Makes things look like you got really close; suddenly everything looks bigger and nearer.

Photo Pro Jargon

A **normal** lens more or less reproduces the world the way your eyes see things. **Wide-angle** lenses make things look small and far away; **telephotos** make them look larger and nearer.

Fixed focal length lenses have only one focal length. **Zoom** lenses let you choose from a range of focal lengths; in addition to the focus ring, they have another ring that changes the focal length as you twist it.

There are also two ways of talking about focal lengths: *fixed-focal length* and *zooms*. Each has its pros and cons, which are explained in the table.

TIFF Luck

One problem with using regular EF lenses with your EOS DSLR is that the focal lengths act differently than this table might lead you to expect. Because the imaging sensor is significantly smaller in size than a 35mm film frame (what the equipment was designed for in the first place), it only gets part of the total image. It acts as though the lens has a longer focal length—60 percent longer, to be accurate. So when you're selecting lenses, keep that in mind and multiply the lens's focal length by 1.6 to get the effective focal length.

Fixed-Focal Length and Zoom Trade-Offs

Fixed Focal Length	Zooms
Pros: Because they're simpler to build, it's easy—and less expensive—to get better optical performance. They're also smaller and lighter than zooms, meaning that it's easier to get a steady shot while holding them in your hands and not using a support. (See Chapter 4 for more information on keeping your camera steady.)	**Pros**: Can you say convenience? One lens can give you a whole lot of choices of focal length, some even spanning from a moderate wide-angle to a moderate telephoto.
Cons: If you want a bunch of different focal lengths, you carry a bunch of different lenses, and the weight can add up. Also, you only get the exact focal lengths you bring and nothing in between.	**Cons**: They are more expensive than fixed-focal length because they have more glass, parts, and gizmos. It's also a lot harder to design a good zoom than it is a good fixed-focal length, which means you'll be spending more. And that lens comes with more weight, which can really pile on if you get the optically better models.

Even if you get a kit with an EOS camera and a lens, chances are good that you will eventually want others. When you do, there are a few things to keep in mind:

- The focal length in millimeters (mm) or the range of focal lengths if you want a zoom

- The lens speed as specified by the smallest f-stop (widest iris opening) the lens has

- That if you are buying a lens made by a company other than Canon, it is EOS-compatible, because chances are the manufacturer also makes lenses with mounts for other camera systems

Here's an example of ordering a short telephoto lens from Canon that is fast enough to work in many low-light situations: "I'd like a Canon EOS 100 millimeter f2.8 lens." You should get what you want—once you pay the clerk, that is.

Keep in mind that the longer a lens's focal length or the faster its speed, the bigger and heavier it's going to be, because the more glass it requires.

Thumbnail Tip

There are other lens companies, such as Sigma and Tamron, which are generally well-regarded by photo aficionados. You can get performance that some say is as good as Canon's own lenses, but for less.

If you are buying a Canon-made lens, you will have to say whether you want an EF lens or an EF-S model (see Chapter 1 for more on the difference between them). There is also a line specified by the letter L—professional grade lenses with the highest performance and highest prices, which are not for the casual photographer.

For just-us-folks shooting, consumer-grade zoom lenses are probably the best choice. You carry around fewer lenses, they don't weigh all that much more than the consumer-grade fixed-focus, and you have a wider choice of focal lengths. Even though I prefer fixed-focus lenses when shooting professionally, on vacation I like to kick back and carry less, which is when the zooms come out.

There are also two specialty lenses that can be handy. One is a *macro*, letting you get very close to your subject—sometimes a matter of inches. A *telephoto converter* effectively multiplies the focal length of your telephoto lens, typically by a factor of either 1.4 or 2. Unfortunately, converters don't work with normal lenses.

Photo Pro Jargon

A **macro** lens focuses at short distances from the subject. A **telephoto converter** multiplies the focal length of a telephoto lens, usually by 1.4 or 2 times. **Lens shades** or hoods help reduce glare and even flare when you're shooting toward a light source. **Lens caps** fit onto both sides of a lens to keep it safe when not in use.

While you're off shopping, be sure that you have front and back *lens caps*, which keep damage from happening to the lens. (See Chapter 10.) And consider getting a *lens shade* as well, to help cut glare. (See Chapter 11 for more on that.)

Work That Lens

After you have a lens, you need to know how to work it. Before even considering taking a picture (see Chapter 6 on focusing and Chapter 7 on exposure talk), it's time to learn how to put the lens on the camera. We'll start with the EF type that you see in Figure 3-3.

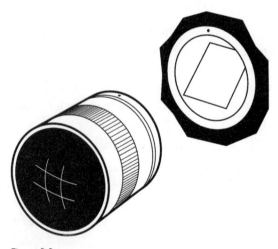

Figure 3.3

An EF lens.

Mounting a lens is nothing more than aligning the lens and body and then turning.

To actually mount the lens, follow these steps:

1. Take off any caps on the back of the lens (the end with the dot) and on the front of the body.

2. Place the lens back up against the body, aligning the red dots. (And, yes, they're black in the drawing.)

3. When the two meet and are flat against each other, twist the lens clockwise until you hear a click.

The EOS DSLR bodies that are compatible with both the EF and the EF-S bodies mean that attaching the lens requires a little bit of thought. The body will have both a red dot *and* a white dot. Although each EF lens has a red dot on it, an EF-S lens has a white dot.

If you're using an EF lens on one of the EF-S compatible bodies, you use the above three steps exactly as written. If, however, you want to use an EF-S lens, then use those steps, only lining up the *white* dots. Now you're armed and dangerous.

A New Pair of Glasses

Anyone who's been outside in bright sunshine knows how much help a good pair of sunglasses can be. Cut that glare and suddenly you again can see things—like that car you were about to drive into. There's an equivalent for cameras: *filters*. By threading a filter onto the end of your lens you can change the way a scene looks, getting a particular effect that can be difficult to impossible to get any other way.

Photo Pro Jargon

A **filter** is a specially treated or tinted piece of glass that fits onto the end of your lens to get a particular optical effect. Some screw into place; others are square and made to slide into a special holder that mounts on the lens.

All lenses have precise threading at the front so you can screw in a lens or an adapter for a lens holder. Each lens is marked on the front to tell you what size thread it has in millimeters.

Oh, sure, go ahead and bring up the digital manipulation that we'll get to in Chapter 14. I'll be the first to admit there are amazing things you can do on the computer. But although you can change color balances, or do some exposure compensation, or trim down the image for more effective composition, you ultimately can't change some things. For example, if glare is bouncing off a window, no matter what you do in software, you won't see what was behind that pane of glass. And yet it's easy to solve that problem with a filter.

Getting Hazy

I love shooting outdoors, but you have some big battles, like atmospheric haze. Suddenly that blue sky looks a bit white, and everything may lose some contrast and seem washed out as a result. A lot of that is due to an excess of ultraviolet light outside, which not only reduces sharpness, but can give a bluish haze to your shots (check Chapter 10).

You can reduce these effects by using either a *UV* or *skylight filter.* The first actually removes some of the ultraviolet radiation entering your lens. The skylight filter is a light pink and works by cutting out some of the blue light. My preference is using a UV filter because when I'm indoors I don't have to remove it, so it acts like an extra layer of protection (see Chapter 9). I'd have to take the skylight filter off unless I wanted to slightly change the colors of everything I was photographing. And if the light really is too blue, I can change that in the camera (Chapter 10 again).

Photo Pro Jargon

A **UV filter** removes some of the ultraviolet radiation found in sunlight, improving contrast and reducing atmospheric haze.

A **skylight filter** has a slight pink color that helps cut haze and reduce any bluish tinge from outdoor light. A **polarizer** acts like a good pair of sunglasses to reduce glare and make some objects, blue skies in particular, more dramatic.

Pass the Shades, Man

One of my all-time favorite filters is the *polarizer*. It's a two part filter. After you screw it onto the lens, you can turn the front portion. The combination acts like a pair of super sunglasses, cutting glare. As have many other photographers, I've successfully used these to take pictures through windows and into bodies of water that were otherwise reflecting a lot of glare.

A polarizer will also darken and deepen blue skies. Ever see in a travel article or book a picture of a beach with a sky so blue that it looked as though you were on the verge of bursting into outer space? Sorry to say it, but you've been had. Many travel and landscape photographers use polarizers to artificially give that rich color. But it looks good as all get out, and there's no reason you can't do the same if you want the same impact.

There are two types of polarizers: linear and circular. Don't worry about the technical differences other than with digital SLRs, you need the more-expensive (sorry) circular type that's compatible with the camera's automatic features.

Special Effects

If what you can gain from UV/skylight or polarizer filters isn't enough, there are acres of specialty filters waiting to be harvested, even if puns go against your grain:

- ◆ *Neutral density.* It might seem odd to have a filter that cuts down on the light entering the lens since the whole point is to get light *in* there in the first place. But it's actually a way to fake out the camera so that you can change the relation between the shutter speed and aperture to get particular effects. (See Chapters 7 and 12.) You specify a neutral density, or ND, filter by the number of f-stops it effectively adds to the aperture.

- ◆ *Cross screen.* Add that literal twinkle to someone's eye, as well as to anything bright in the image.

- ◆ *Graduated.* Some photographers use a red graduated filter to add a sunset or sunrise effect to the sky without coloring the landscape

and making you think the picture came from Mars. A graduated neutral density filter can be incredibly useful when you want to take pictures of early morning or late afternoon skies but the sun is so powerful that you can't get a single exposure that lets you see both sky and land.

◆ *Multiple image.* When you can't get enough of something and don't want to play around on the computer, this special effect filter gives you more of what you crave.

Photo Pro Jargon

A **neutral density** filter cuts down the light getting into the lens. **Cross screen** filters cause bright objects or lights to seem as though they emit distinct rays or lines of light. **Graduated** filters have a color that changes in hue from one side to the other, at which point the filter becomes clear. Another special effect filter is the **multiple image**, which turns an image into multiple copies of the same scene. **Step-up** and **step-down rings** let you use filters that are, respectively, smaller or bigger than the lens you are using.

To me the multiple image and cross screen filters are gimmicky, but there are people who like the effects, and getting the pictures to come out the same way through digital manipulation can take more time than it's worth. As for the others, they have lots of practical uses that you start to appreciate, particularly after you buy them and need to rationalize the purchase.

Saving Some Bucks

Although I really like filters, they can be expensive, particularly if you get top-grade ones that are a match in optical quality for your lenses. But there are some strategies to reduce expense.

One is to use square filter systems. You attach a holder to the front of the lens and slip in the filter, letting you use the same ones with all of your lenses. All you need to have is a set of adapter rings for each size lens front element you have. I find this approach best for such filters as neutral density or graduated.

For some other types of filters—especially polarizers, which have to be turned in place to work—I prefer to have it right up next to the lens. In that case, I look through my lenses, pick out the largest size, and buy the filter for that one. Then I get a set of *step-down rings* so I can use the filter with my other lenses. Although there are *step-up rings*, you have the risk of vignetting the image and having a dark space all around your picture.

TIFF Luck _____

Don't try to save money with your UV or, if you must, sunlight filters. As I say in Chapter 9, they become cheap protection for a lens, and the whole point is to have your entire collection covered at the same time.

The Least You Need to Know

◆ Focal length tells you what kind of image the lens will give.

◆ Don't forget the 1.6 factor to see how a given focal length will act with your camera.

◆ Use the right lens jargon to specify the one you want.

◆ If buying a lens made by another manufacturer, be sure to specify that you need an EOS mount.

◆ If your camera can use EF-S lenses, make sure to line up the same color dots when mounting a lens.

◆ Filters can improve your images.

Part 2

The Basics

There's lots EOS cameras can do for you, but only if you learn what you need to do for yourself. Chapters 4 through 9 cover not just what you need to use your camera, but to take pleasing photos.

Each chapter focuses on a specific area of photographic knowledge and technique, including properly supporting your camera during shots, accurately focusing, how exposure works, examining images after you take them, and protecting your investment in the equipment.

4

Steady as You Go

In This Chapter

◆ Holding the camera

◆ Using tripods and monopods

◆ Improvising support

There's lots to know about how to get a good shot, but you might say that the foundation is a strong foundation. In other words, you have to learn how to hold and steady the camera.

Are you saying, "Come on, now, an entire chapter on holding the camera? Isn't that a bit extreme?" Not really. The foundation of a clear and pleasing photo is keeping the camera steady so you don't blur the image. That's easier said than done. Look at most people using a point-and-shoot digital camera. How do they see what they want? Right, they hold the cameras away from their faces and watch the screens on the camera backs. That almost guarantees your hands will shake. The movement may be imperceptible to you, but it will appear as blurred pictures.

Hold It, Bub

The first rule—yes, rule—you must learn is that holding your EOS DSLR is completely different from that point-and-shoot. For one thing, it's heavier. It's also bigger. But the largest difference is that you don't look at the LCD screen on the back of the camera to see what you're about to photograph. You only use the *viewfinder*. And that means plastering your face right up against it. Try it—hold the camera at the sides and place the viewfinder nice and friendly up against your eye.

> **Photo Pro Jargon**
>
> The **viewfinder** is the part you look through at the top of the camera to see the image you're about to take.

> **TIFF Luck**
>
> Up close and personal, you'll still need to see what's in the viewfinder. And if you wear glasses, you may need them to use the camera. All the EOS cameras have a diopter adjustment—a little wheel on the viewfinder that lets you compensate for your vision, or lack of it. I don't use it myself, though I need glasses; I found that I had to keep propping my glasses up on my head to look through the viewfinder, then put them back again to look without the camera. However, you may find keeping your glasses off to be a great benefit. Experiment a bit and see what works best for you.

Stand there for a minute at most. Notice something? Like the camera starting to feel as though it were made of lead? That's because it's off balance and pulling away from your face. What you need to do is learn to hold the camera correctly.

Now try something a little different. First, if you didn't follow the directions in the manual and attach the neck strap, do it now, then put the strap around your neck so the camera is right side up and the lens faces away from you. Then follow these steps:

1. Put your feet slightly apart, your left foot slightly ahead of the right.

2. Put your left hand palm up under the lens, cradling it and taking the weight, like in Figure 4.1. That leaves your right hand to steady the camera and operate the controls.

3. Lock your elbows into your sides and hold your breath.

4. Press the shutter button.

Figure 4.1

An example of holding the camera steady.

After you've taken a picture, relax your arms and start breathing again. (That last part? Really important.) Holding the camera this way will make it easy to take shot after shot.

Thumbnail Tip

When you switch to a heavier lens, the center of gravity of the camera shifts forward. To counter it, let your hand slide forward just a bit. If the lens is heavy enough, take the heel of your hand right off the camera bottom and completely on the lens.

That last figure was for a horizontal photo, where the image is wider than it is tall. But there are going to be plenty of times that your

subject—a tall building, a waterfall, an NBA player—lends itself to a vertical treatment. The stance is pretty much the same, except that you rotate the camera by 90° so your right hand is up, just like in Figure 4.2.

Figure 4.2

Holding the camera steady for a vertical shot.

There's a rule of thumb: you can handhold a camera and get a sharp picture so long as the inverse of the lens focal length is larger than the camera's *shutter speed*. As an example, say you're using an 85mm lens. The inverse would be $\frac{1}{85}$. When you shoot a picture, if the shutter speed is faster than $\frac{1}{85}$ of a second, then you should be fine. (Chapter 3 has the scoop on lenses and Chapter 7 discusses shutter speeds, among other things.)

Photo Pro Jargon

Shutter speed is how long the camera opens the shutter to expose the sensor to light from the lens.

Like all rules of thumb, it's an approximation. I've taken shots using a fixed-focal length 200mm lens with a shutter speed of $\frac{1}{30}$ of a second. It required big-time

breath holding and taking a few shots in case I moved on some. (I did.) I still got what I wanted, so don't necessarily give up just because some rule says that you should.

However, there are going to be times that handholding the camera isn't going to be too effective, such as …

♦ You're using a very slow shutter speed.

♦ You want to be able to take more than one picture without changing the angle of your shot.

♦ For whatever reason, you don't trust your steadiness.

♦ You'd like the insurance of knowing that you'll get an absolutely rock-steady picture.

At such times, you need a little help.

Support Group

When you need extra steady shooting, you need either a *tripod* or a *monopod* equipped with either a *ball head* or a *pan/tilt head*, like the gear in Figure 4.3.

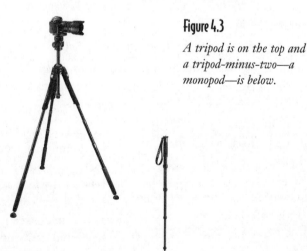

Figure 4.3

A tripod is on the top and a tripod-minus-two—a monopod—is below.

Photo Pro Jargon _____

Tripods are three-legged devices that act like stands to steadily hold cameras. A **monopod** is a single column that helps steady a camera, though not as well as a tripod. Both **ball heads** and **pan/tilt heads** sit atop the tripod or monopod and let you position the camera to the angle you want. A ball head moves freely in any direction and has a single control to lock it into place; a pan/tilt head has two controls—one for forward and back and the other for side to side.

The head screws into the tripod or monopod. It, in turn, has a screw that fastens into a standard threaded hole in the bottom of your camera. (If the lens is particularly big and heavy, it may have its own threaded hole, in which case connect the head to that.)

That screw is typically part of a removable platform, so you connect the platform to the camera and then, following the manufacturer's instructions, attach the platform to the head.

A good tripod or monopod head should have a built-in level so you keep the camera fair and square. Of course, you are free to ignore that if you want something more "edgy." The head should also have a way of tipping the camera 90° so you can get a steady vertical shot as well—no orientational bias there.

The tripod or monopod itself will collapse down to store and carry around. There are all different sizes, but in general the bigger the unit, the taller it can rise. That's important if you're tall and don't particularly want to stoop over to use your camera.

Thumbnail Tip _____

If you're on uneven ground, just adjust the legs to different heights so when you look at the tripod from the side, it doesn't appear to be leaning.

To use the tripod, spread the legs apart and drop them down then lock them into place. You want to rely on the legs as much as possible and any center column as little as possible (except for those final height adjustments). When you start raising the center column, you begin to support the camera at a single point instead of the

more stable three legs—and you don't want all those product engineers to think that their time was wasted, do you?

A monopod is a bit trickier to use. Because it only has one leg, something has to act as the other two—and that something generally is you. Here's what to do:

1. Extend the monopod a little longer than you would if you had the camera where you wanted it and were dropping the leg straight down.

2. Set the foot (bottom of the leg) ahead of you.

3. Lean the camera back toward you, tipping the monopod to you.

4. Tip the camera forward so that it's level.

You are providing a sizeable (in my case, quasi-enormous) anchor. Although the results aren't quite as good as a tripod, when you get a feel for it, the approach works really well. Figure 4.4 should give you a good idea of how to do this.

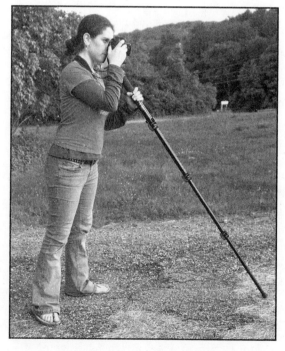

Figure 4.4

When using a monopod, you provide extra stability.

News Flash _____

Manufacturers are using new materials all the time, trying to create rigid tripods that are still light. Carbon fiber units have become common, and tripod vendor Manfrotto is actually building lines out of basalt—volcanic rock that is sturdy and much lighter than aluminum. However, if you're going to be in heavy winds, you want not only rigid, but heavy, and a traditional steel monster may be your best choice

Sometimes a traditional tripod or monopod isn't the best solution. There are special tripod models small enough to sit on a table. One type of camera support actually clamps onto a car window so you can shoot without leaving your mechanical horse.

But what happens when you go out and plumb forget the tripod or monopod, as I've been known to do? Improvise.

Make Do

The underlying principle of keeping a camera steadier than you can hold it is to make use of the nearest quasi-immoveable object. That could be:

◆ A tree

◆ A wall or column

◆ The ground or floor

Look around to find something that isn't going much of anywhere, then lean or rest on that involuntary volunteer. I can remember once taking a picture of a caleigh—a musical get-together—on Prince Edward Island by standing outside the packed building, pressing the very front edge of my lens (the outermost element was recessed enough to make it safe) against a window, and getting some great pictures.

If you're worried about getting the camera dirty or scratched, particularly if you're earth bound, put your camera bag (see Chapter 10) down first and rest the camera on that. I recently had to photograph a

theatrical performance and tipped my bag up on end, rested it on my lap, then put the camera on top of that. Remember: where there's a will, there's a way.

The Least You Need to Know

♦ Cradle the camera in your left hand and balance with your right, then squeeze your elbows and hold your breath.

♦ Try to use a shutter speed smaller than the inverse of the lens's focal length.

♦ Use a tripod or monopod when steadiness is particularly difficult or critical.

♦ When you don't have the right support, improvise.

Chapter 5

Framed!

In This Chapter

- ◆ The importance of composition
- ◆ Creating a visual focus
- ◆ Creating harmonious visual relationships
- ◆ Catching problems early in the viewfinder

You've seen lots of bells, whistles, and technology up to now, and you'll see plenty more in upcoming chapters. But with all those bells and whistles making all of that noise, you can forget that taking good photos is, ultimately, about the eye of the photographer. And that's you.

I remember hearing a story about the original version of *The Manchurian Candidate*. Frank Sinatra was performing a scene and nailed it the first time. Unfortunately, it turned out that the camera was slightly out of focus. So they tried re-filming it—and re-filming it. At the end, the first take was the only one with the quality they wanted, and that's what they used. What was in the scene was more important than how it was filmed. (Ironically, the critics praised the daring of visual aesthetics as societal critique.)

There's an old saying that a good photographer can get a superior shot out of an old Brownie camera. The essence of a good photograph is the same as for all visual art—*composition*. Wording it a little differently, in this chapter, you're about to learn to put your photo subjects in their places ... in your viewfinder.

Let's Pay Attention, People

But when you're putting things into their places, not all things are equal. Number one on your list—outside of good looks, keen intelligences, and fabulous wealth—is your subject. There's a reason you're taking a picture, probably because you want to see and remember something the way it was.

But you've seen plenty of pictures cluttered and confused, where your eye wandered all over the place. To get people to look at your subject, you have to make it the *visual focus*.

> **Photo Pro Jargon**
>
> A photograph's **visual focus** is the part that draws the viewer's eye. **Composition** is the art of arranging visual elements to create an intended effect.

It's a touch overstated to turn someone's head in the right direction and stab at the picture with your finger, all the while shouting "There! There!" I may not be above it, but you undoubtedly are, so we'll discuss some other ways of getting people to pay attention to the right things.

The practice, as old as painting and drawing, is composition—one word standing for a collection of techniques to entice the eye, highlight what is visually important, and otherwise nicely push viewers around without their knowing it.

Artists have long known how to construct their work to control how their audiences perceive them, employing composition. In fact, one of the most effective (and fun) ways of learning composition is to visit a good museum and look at classic paintings and drawings.

Of course, it could take a pretty long time to notice every technique and see how to put it into practice, so we'll take a shortcut, using a set of tricks. You can combine them to add to your pictures additional snap, crackle, and pop (and any other cereal-related words I've forgotten).

Visual Focus, Front and Center

Any picture should tell a story. You don't need to go the *War and Peace* route, and the story may have as much to do with mood and feeling as it does with something in particular happening. But if you identify a subject and, to the best of your ability, what you are saying about it—what made you want to take the picture—then you're well on the way to better pictures.

That subject of the story you're telling needs to be the visual focus. It may be about one person or a few. Your interest might be in a single flower or the view from a mountain top. But you need to choose what you are photographing.

Now having the subject of a picture being the visual focus of a picture probably sounds pretty obvious, and it is. However, there's a big difference between knowing what you need to do and pulling it off. Did you ever have something catch your interest, so you pointed the camera and clicked away, only to be disappointed with the results?

Thumbnail Tip

When you look through the viewfinder, you see what the imaging sensor will see—kind of. As with most cameras, what your eye sees is actually cut down a bit from what reaches the sensor. In fact, you might only be seeing 95 percent of the final picture. Although 5 percent may not seem like a lot to miss, you'd be surprised. Take some pictures, deliberately placing some natural horizontal line at the top or bottom of your frame, or a vertical line to one side or the other. Now look at the LCD screen. Chances are you'll see things that weren't visible to your eye when taking the picture. We'll learn how to handle the excess in Chapter 14, but it's best if you can anticipate what else will be in the picture.

Barring some technical glitch such as the picture being too dark to make anything out or all blurred, the likely problem is that you didn't choose a subject and then *let the viewer know.* The subject might be a person in a crowd, or a flower sitting near a lot of other green things. What you need to do is find a way to make your subject stand out.

A basic way to grab the attention of your audience is to put the subject so forward and center in the image that there's no way to ignore them, as in Figure 5.1.

Figure 5.1

The subject is the action in the center of the frame.

Sure, there can be other things happening, but they're so piddling in comparison that your eye doesn't drift away. We've filled the frame of the image.

Don't worry, though—you don't have to make everything so visually blatant. There are other ways of focusing the eye on the subject. Going

back to the example of pho-
tographing a flower, another
example is using *selective focus*,
as in Figure 5.2. There are
a number of flowers in the
image, but your eye goes to
the one with a dewdrop on
the inside of a petal.

Photo Pro Jargon

Selective focus is a
technique in which you
direct attention to the
subject of your photograph by
having it be the sole object in
focus.

Figure 5.2

Your eye wants to see what's in focus, not what's blurry.

It's a natural reaction: Who wants to spend time looking at something
that you can't really see anyway because it's out of focus? By leaving
most of the image fuzzy, you leave the viewer little choice but to look at
the one item that is clear.

While you're making subjects stand out, look at visual contrast. Your
subject might be a lot darker than the rest of the image, or much
lighter. It could have a different looking texture, like putting a por-
cupine in a mass of marshmallows. Something—like a racing child—
could be moving at a speed different from the surroundings of a
shuffleboard tournament in a retirement community. Like Figure 5.3,

you might have something that's just very orange—as the outdoor art installation, The Gates, was in comparison to everything else in New York's Central Park. (Or in the case of a black-and-white translation, maybe very pretty light gray would be the term.)

Figure 5.3

What's clashingly different is what's obvious.

You may notice something peculiar going on—so far, each technique is isolating the subject in some way or another from everything else in the picture. It should become the modern superpower of the visual world, at least as far as this picture goes. In the next photo you take, you'll probably choose another subject—you fickle person, you—causing a complete shift in the inter-optical balance of power.

Using some visual element as a way of building a frame around an object is another traditional way of setting off your subject. What? Using a frame within the frame of the image? My recursive heavens, we've been framed.

In Figure 5.4, you see the result of my trip to the Museum of Science in Boston when I looked at a real computer made of, I kid you not, Tinker Toys. I didn't have to kid, because there were two kids right there also

looking at it. Having them pose next to the display would have been trite, so I got them to stand on one side of it and I was on the other. Shooting through, I made the subject their eyes, and used the computer's parts as a frame that not only directed attention to the subject, but that added a reference to the original materials. I'd pat myself on the back, but obviously I'm too subtle for that.

News Flash

Although good photographs are sometimes planned—putting people and things where you want—that's only one approach. An entire school of photographic aesthetics says to take the world as it is and not to change things. But even then a photographer will move all over the place, climbing up on something, lying down on the floor, to find the best angle for composition.

Figure 5.4

Another way of saying that walls make good visual neighbors.

You can also use other parts of the picture to point toward your subject. Don't plan on putting up a bunch of arrows painted on cardboard all

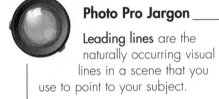

Photo Pro Jargon

Leading lines are the naturally occurring visual lines in a scene that you use to point to your subject.

pointing in the right direction. Instead, you look for *leading lines* in the scene and move your viewpoint to take the best advantage of what they can do for you. If the lines all converge at the subject, then every time your viewer's eye strays, it's directed right back to where you want it to be.

Figure 5.5 is of talented actress Alexandra McDougall, who also happens to model. We had just done a little shooting for fun and she was putting her hair up. Notice how the lines established by her arms and clothing all lead back to her face.

Figure 5.5

Leading lines to your leading player.

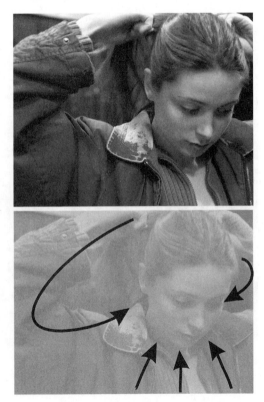

But with all this emphasis on the subject, how about the rest of the picture? Are we dividing the world into visual classes? Can you expect

some photographic Karl Marx to erupt and demand that the second-
ary elements of your picture take over, pushing your subject into the
background and instituting cacophony? (Alright, it's an audio term, but
cut me some slack.) Nope—you're going to learn how to maintain har-
mony.

Can't We All Get Along?

For all the talk of the visual, it actually is surprising how often the
audible seems applicable. What you want is harmony among the ele-
ments of your picture, and a rhythm that helps establish a mood and
keep the audience looking. To get that, you need good relationships
among the parts of your photos.

The literally classic advice you might have heard is the *rule of thirds*.
Divide what you see in the viewfinder into thirds, as in the top of
Figure 5.6, and you get proportions that are close to the *golden mean*.
By placing your subject at the intersections of the dividing lines, you
get a good balance of place-
ment within the frame. At
the bottom, you see how I
used it in a picture of actress
and model Christine Voytko.
Her face falls almost perfectly
at one of the intersections.
In very little time you'll be
finding that placement even
without drawing lines on your
viewfinder. (No! Don't do it! I
was just kidding!) It's because
this proportion is built into
so much art and architecture
that you've grown up with it
and become accustomed to it.

Photo Pro Jargon

The **rule of thirds** says
that if you divide the
height and width of what
you see in the viewfinder into
three parts, having important ele-
ments in the left or right or upper
or lower third is aesthetically sat-
isfying composition. The **golden
mean** is an ancient ratio that
results in pleasing proportions.

But that's just one way of relating one part of your picture to the rest
of the image. Another way is to contrast the scales of different parts
of your image. If you see a picture of something particularly large by
itself, it can seem abstract. After all, just how big is it?

Figure 5.6

Getting ready to apply the rule of thirds.

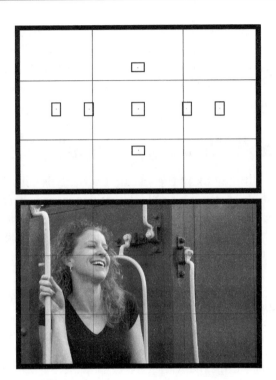

One way to telegraph the size is to include something that people recognize and use it as a ruler, showing other sizes in relationship, as in Figure 5.7.

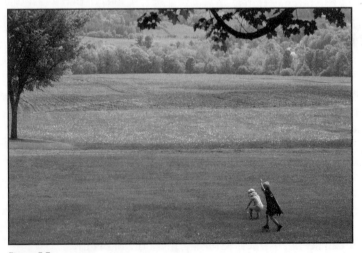

Figure 5.7

The kids give a sense of the field's size.

You also want to make sure that no one part of the picture overwhelms another, which is why you have to consider *visual weight.* This concept is a little slippery. Objects can provide visual weight from their mass, but you can also get weight from a smaller object out in empty space, like a visual seesaw, as you can see in Figure 5.8. The figures on the left practically become part of the rocks. The fisherman on the right, however, carries significant visual weight just because he's off by himself, and so he commands more attention.

Photo Pro Jargon

Visual weight says that parts of your image have an emphasis, and ideally you want to balance these so the picture doesn't seem lopsided. **Negative space** refers to the blank areas of an image.

Figure 5.8

Waiting for the one that didn't get away yet.

Speaking of empty space, otherwise known as *negative space,* it can become as big an element of your composition as anything else, as you might notice in Figure 5.9. There is next to nothing on the right-hand side, yet that lack helps define the placement and arrangement of the arm with its painting equipment.

Negative space is visual elbow room—you give the eye some relief by everything it thinks it has to look at. It can help isolate a subject, create contrast, balance the visual weight of one strategically placed object

against another part of the picture, and otherwise work miracles. You can also help create more negative space with some of the other compositional tools. For example, in Figure 5.9, I deliberately used selective focus to blur into oblivion the background on the right-hand side to help create that negative space.

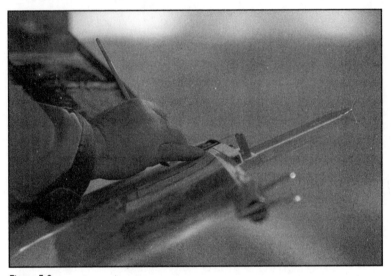

Figure 5.9

Sometimes what is important is what you don't show.

TIFF Luck

Just as element placement in a picture can lead to better composition, if you're not careful, it can do just the opposite. Look at the whole frame for what might work against you. Are there parts of your image creating visual lines leading away from the subject, or does visual weight in one part of the image draw the viewer's eye from where you want it?

At times the flip-side of using negative space can also work. In Figure 5.10 you'll notice birds. A whole bunch of birds. Not just birds of a feather, but birds that look as though they were stamped out of the same mold. I'm guessing it's because there is some termagant factory that figured it had gotten things right, so why mess with the style?

But while all the birds leave precious little space for anything negative, their number creates an almost physical rhythm in the

image. Repetition can be a strong element in composition, particularly if you have one of the individually repeated elements different in some way. For example, you could have a crowd all looking one way, but one face turned another way.

Figure 5.10

Using repetition and rhythm to aid composition.

Also remember that you can change the relationships in your pictures by varying the way you hold the camera. Chapter 4 mentions tipping the camera on its edge for a reason. If things don't look quite right to you, try a vertical composition instead of a horizontal one; it will give you a whole new view of the picture.

Sights Unseen

Although I've been concentrating on what to see, the last note brings up an important subject: what *not* to see. When I get in the throes of taking pictures, I can get carried away and not make those last checks of what could mess up a picture that I definitely don't want to see in

the final image. Here's a quick list of what can be problems and ways to solve them:

- Busy backgrounds can distract from your subject and draw someone's eye away. Try shifting your position relative to the subject, getting the subject to move or using selective focus to blur the background.

- Often scenes will have natural horizontal and vertical lines—like a tree or the horizon. If you're not careful, they can look tilted and make everything look odd. Even if they are *naturally* tilted, your audience will assume that you're the one who's tilted (unless it's really obvious that there should be a tilt). You can line the horizontal or vertical lines up with the edges of your viewfinder to get closer to level. If worse comes to worst and you do make a mistake, you'll learn in Chapter 14 how to fix that with an image editor. (Not that it happens to me; no, I just learned it for a more well-rounded photographic education. Yes, that must be it.)

- A basic problem with optics is that if you tip a camera and look up or down or along something's side, you'll find that formerly parallel lines will start to meet. Point a camera up toward the top of a tall building and you'll see what I mean. One solution is to use something called a view camera—the one that looks like a box where the photographer throws a cloth over his or her head—but that's pretty impractical. So is using a special type of lens called perspective correcting, which lets you tilt things back to normal, but that's also a lot of money. However, your computer and an image editor (Chapter 14 shows how to edit images) will let you stretch your picture this way and that and bring things more or less back to normal.

- Although you will see how to control exposure in Chapter 7, you should know right now that if two things are close to the same shade, they may blend into each other. This can lead to some pretty funny things, like having a person in a black turtleneck in front of a black background and getting a picture of a floating head. (Well, *I* thought it was funny when I did it.) Your choices are to increase the lighting on one of the objects (Chapter 11 has more on lighting), move the subject, get the subject to change

clothes, or use your digital darkroom to change the image contrast enough to separate the two. (Chapter 14 shows how to change the contrast of an image after you take it.)

◆ If you're in a hurry to take someone's photo, you can inadvertently become a surgeon and lop off some part of the body or head. If you do it to a great enough degree, you could try to bluff your way out and call it artistic. Otherwise, pay attention when looking through the viewfinder.

◆ You can also become a Dr. Frankenstein and add things that nature never intended. Juxtapositions between subjects, foreground, and background can make for some odd effects, like the telephone pole behind your cousin Rita that will look as though it's growing out of her head. You'll need to move yourself or the subject or be ready for some intensive computer work to actually retouch significant portions of the picture—possible, but a big pain in the shutter finger. If the pole actually is growing out of her head, there's probably nothing I can do for you. Or her.

After you get a handle on composition, getting control over the rest of what your camera does will leave people gasping, "Wow, that's really good!" Then it will be time to practice saying "Thank you" with a modest tone of voice.

The Least You Need to Know

◆ Decide what story you want to tell.

◆ Use compositional techniques to direct the eyes of your audience.

◆ Arrange your compositions so components of the image work together and don't fight for attention.

◆ Catching and fixing compositional problems in the viewfinder is always the cheapest, easiest, and fastest solution.

Chapter 6

Looking Sharp by Focusing

In This Chapter

- ◆ Finding your focus point
- ◆ Do it yourself or let the camera do it for you
- ◆ Making depth of field work for you

Nothing makes a photograph more disappointing than bad focus. Okay, so sticking your thumb in front of the lens is worse, but you'd notice in the viewfinder. Grab a fuzzy shot, though, and no matter how good the composition, how compelling the subject, how dramatic the lighting, the picture is going to disappoint you.

What? You've seen professional pictures that are out of focus? That's right—intentionally. Generally only part of a picture will be blurry, with one part in focus so your eye goes right there. Sometimes portraits will deliberately have a slightly out-of-focus look, a technique that is particularly good at flattering people's appearances as well as hiding wrinkles. And sometimes images look as if someone took them through a fun house mirror. Then they're called "art."

But you want photographs that you can share and enjoy and be proud of, and not that are just out of focus enough that you find yourself apologizing to everyone that seems them. That's why learning to focus—and to keep the focus only where you want it—is so important. Luckily, the Canon EOS line can help you do that, even if, like I, you have aging eyes and battered glasses. Let's learn how to get the image in focus where you want it.

Focusing the Shot

The first thing to realize is that with any DSLR you don't focus the camera—you focus the lens. Every EOS lens will have at least two things in common: a focusing ring and a switch that lets you choose between MF (*manual focus*) and AF (*auto focus*). This is true whether you have a Canon lens or a compatible lens made by another company. (You can check the picture of a lens in Chapter 4 to see the features.)

Photo Pro Jargon

Manual focus is when you focus the lens instead of letting the camera do it. **Auto focus** is when the camera focuses the lens for you.

Both auto and manual focusing work on the same principle: the observation that the sharper the image, the more difference you see between adjacent shades of light. Figure 6.1 shows this in action.

Figure 6.1
The sharper the focus, the greater the contrast.

On the left side, the transition between one shade of gray and the other is abrupt. But on the right side, the two shades blend into each other,

and the effect is that of a blurred line—the different grays blend into each other where they meet.

Notice how the left side looks sharper while on the right side the line between the two shades is blurry? This is exactly what happens in focusing an EOS lens. At first, places where two regions of different colors or even various shades of the same color meet will look blurred— meaning that the regions into each other.

As you turned the lens's focusing ring and the image comes into focus, the colors or shades blend into each other less and less, and adjacent regions become more distinct. If you kept turning the focusing ring, the edges of the regions would start to blend into each other again. So you would need to turn back so you could again bring the image in focus.

If focusing is normally critical, it becomes vital when you want to edit pictures because in the process you'll end up making them bigger—either the entire thing, or parts. When that happens, not only do you see more detail, but all the shortcomings are more visible as well. Too often has been the time that I've taken a shot and enjoyed the composition on the preview screen only to find that when it's bigger, what seemed sharp suddenly turned as *soft* as an ice cream cone on a Miami street in July.

There are things you can do to help keep shots more in focus; in fact, we looked at some in Chapter 5. However, the most important thing is to learn to focus correctly. We'll start with doing it the old-fashioned way—manually— before we go to auto focus.

News Flash

Being in focus is like art—you know it when you see it. But what you're seeing is when adjacent regions of colors or shades of the same color are as distinct as possible.

Photo Pro Jargon

Soft means a bit out of focus. A picture can be more soft or less soft, and it can be the result of a mistake (most cases) or intentional (when I do it and need an excuse). If it's really out of focus, there are a few other technical terms: blurry, fuzzy, or "What the *heck* am I looking at?"

Do It Yourself

The traditional route is manual focus. Here are the steps to follow:

1. Flip the switch on the lens to MF.

2. Choose the most important part of your picture. That's the one you want to be sure is in focus.

3. Hold the camera viewfinder up to your eye and look at the subject.

4. Watch the viewfinder as you turn the lens's focus ring. Concentrate on the important part of the image. That part will keep getting sharper until it can't get any better, and then it will start to get fuzzier again. When it does, start the ring back the other way s-l-o-w-l-y until the image again looks sharp.

5. Press the shutter button and take your picture.

If the image doesn't seem to be getting sharper, you may be turning the ring in the wrong direction, so spin it back the other way. And if you're using a zoom lens and the image keeps changing sizes, you've just grabbed the zoom ring instead.

Especially at first you may find yourself twisting the ring back and forth, trying to find the point at which the image is in best focus. Chalk it up to learning; as you practice, you'll find that you can put a scene into focus quickly.

Thumbnail Tip _____

One of the tricks to good manual focusing is freeing your grip enough to turn the ring. Hold the camera body steady with your right hand (yes, I know, it's unfair if you're a lefty, but that's where the grip and life are) and turn your left-hand palm up. Balance the bottom of the body on the heel of your hand. Now you can gently curl your fingers around the lens, steadying everything, while still being able to turn the focusing ring.

One way of getting better focus is concentrating on parts of the image that are easy to focus on. That means areas where you will see different colors or different shades of a single color up next to each other. It's just like with Figure 6.1. You'll be able to more easily see whether or

not the colors or shades are blending into each other where they meet. Some excellent candidates are strong geometric patterns, such as stripes or checks, particularly in clothing. Sharp edges on buildings or objects are another place to focus on.

Personally, being a little bit lazy, I find it handy not to think too much about the mechanics of focusing. That's why I prefer to use auto focus when I can, which is most of the time.

Auto Focus, Please!

Auto focus has become old hat for many cameras, but it's still amazing when you think about it. The type on the EOS line is passive auto focus. That doesn't mean that the camera actually waits for *you* to do something. Instead, it acts pretty much like you would.

The camera has sensors called *AF Points*, connected to the body's computer, which watch the image reflected off the mirror and up toward the viewfinder. The sensors look for those differences in shade and color—actually the intensity of the light, which works out to pretty much the same thing. The computer chip sends a signal to the lens, which has a built-in focusing motor that kicks in, having the same effect as turning the focusing ring.

Photo Pro Jargon

An **AF Point** is one of the rectangles you see in the viewfinder. Each one can be the place where the camera's auto focus looks to focus the image. You can select a particular AF Point, or the camera can do it for you.

Depending on the lens, there are actually three different types of auto focus motor you could be using: Arc Form Drive (AFD), Ultrasonic, and Micro Ultrasonic (refer to Chapter 3 for more information on lens auto focus motors). Forget about the technical minutiae—whenever possible, choose lenses with the regular Ultrasonic motor. They are dead silent and, as they say up in New England, wicked fast.

Making Auto Focus Work

Yes, it's called auto focus, but you *knew* that you would have to do something. Your role starts with looking inside the viewfinder. You can actually see the positioning of those AF Points: they're the little rectangles. Figure 6.2 shows you what the 30D and Rebel XT viewfinders look like. If you have another model EOS digital SLR, things may look a bit different in the viewfinder, but the steps are the same.

Figure 6.2

The viewfinder on the top is the 30D; on the bottom is the Rebel XT.

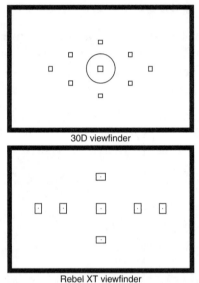

30D viewfinder

Rebel XT viewfinder

There are some differences between the cameras. The 30D has smaller sensors than the Rebel XT and more of them. The Rebel's sensors stretch out farther both vertically and horizontally. Practically speaking, it means that the 30D has finer auto focus control. Because that camera has smaller sensors, it looks at the sharpness of smaller areas, so even minor differences in light intensity stand out more.

Using Auto Focus

Actually using auto focus is easy, and the basic operation is the same for each camera. Just use the following steps:

1. Be sure that the switch on the lens is set to AF.

2. Choose the most important part of your picture. That's the one you want to be sure is in focus.

3. Hold the camera viewfinder up to your eye and look at the subject.

4. Press the shutter button halfway down. You'll hear the slight whir of the auto focus motor and see the image suddenly get sharp.

5. Now you can press the shutter button the rest of the way and take your picture.

It sure is a lot easier than the manual method for those of us with advanced degrees in lethargy.

Select the AF Point

However, there is one catch in the whole auto focusing scheme. When you focus the camera manually, you are watching the important area of the image to see when it is in focus. Although the EOS cameras are smart, they're not mind readers.

Luckily for you and me, Canon already thought of that. Go back to Figure 6.2 for a second. Notice that each of the cameras has a number of AF points. You can choose which of them you want to use. Here's how:

1. Select an operating mode that lets you select the auto focus point. (Chapter 2 has more on operating those operating modes.)

2. Decide what part of the image is the most important to be in focus.

3. Press the AF point selection button on the upper right corner of the camera's back. (See Chapter 3 for the actual position of all controls.)

4. Now it's time to actually choose the AF point that's closest to the object of your eyefection (or affection). The cameras vary in

Thumbnail Tip _____

Some of the camera's operating modes even make the auto focus decisions for you. If you set the 30D for A-DEP or any of the basic zone modes (as Chapter 2 explains), the camera will choose what it considers the best AF Point to use.

how you actually control the selection, so check your manual for the details you'll need to use. You'll know which one is currently picked: either the AF point's rectangle or a dot in the middle of that rectangle will turn red.

5. You can select automatic AF point selection if you want to, or even if you're not careful. (You'll know it's on automatic if all the AF points light up.) Again, this varies by the camera model. On the 30D, for example, that happens in two ways. One is when you've selected some AF point other than the center and then you push the multi-selector again in that direction. Or you can keep turning either the quick control dial or the main dial to eventually light all the AF points. On the Rebel, if you push the cross keys to go beyond where there are AF points, then all of them light.

Thumbnail Tip

If you have achieved the level of indolence I enjoy, you may not want to even exert yourself enough to change the AF point. Or, for those who are a bit more industrious, it could be that an opportunity for a good picture is fleeting and you want to capture it as quickly as possible. No problem. In such cases, move the camera to position the active AF point over the most important part of the image, no matter where it may be. Now press the shutter button halfway down. That locks the auto focus. Keeping your finger on that button, move the camera back again, so that you have the composition and framing that you want. Now press it the rest of the way down to get that picture.

After you have selected the AF point, make sure that it is positioned over the part of the picture that you decided was important and press the shutter to take the picture.

Focus Mutiny

Unfortunately, convenience has the darndest habit of going off for a walk just when you want it most. There are conditions that make it really hard for the camera's auto focus system to be able to do its job, such as when near and far objects appear to overlap, at times when you are shooting in low light, when your subject is close to one color, or if there is a lot of reflection. In other words, your camera's eyes start crossing.

If you're in low light, the camera will actually do its best by opening the built-in flash and setting off a series of short light bursts to get enough contrast so the auto focus can work. However, it will only reach about 13 feet, so if you're trying to get a picture of Mount Fuji at dusk, you'll be out of luck. If the flash might irritate a subject or offer an alert when you're trying to take a candid photo, then you can use the Landscape, Sports, or Flash Off operating modes to keep it closed.

> ### Thumbnail Tip
>
> When the camera thinks that things are looking bad—well, just not looking at all—it's often because it's trying to focus on some part that is too difficult a subject. But there may be other parts that are the same distance from the camera and that may be far better focus fare. In such cases, point the active AF point at that part and use the AF lock trick from above.

Luckily I've found in my experience that the auto focus system usually works, and that has been in all sorts of conditions. But with all the help in the world, there will still be times like that you'll be thankful that you learned to focus your camera manually. (You didn't really think that I'd have gone through all that if it wasn't necessary, did you?)

That means manual focusing and, to do so, you might have to flip the switch on the lens back to MF. Why do I say might? Because a lens with the Ultrasonic (not Micro Ultrasonic or AFD) motor lets you use the focusing ring even when the lens is switched to AF. Generally you'll still use auto focus first and then, if auto focus doesn't work, twist the focusing ring until things are perfect. It might make you wonder why they have the switch on these lenses in the first place, but there's a rea-son. If you are determined to manually focus, you won't want the cam-era to auto focus after you have everything set and you start to press the shutter button.

Which Way Did He Go?

Yes, auto focus is a convenience to love. But what happens when the subject doesn't want to cooperate? Maybe there's a child or other type of wild beast on the loose. Perhaps you're trying to keep that outfielder

in focus as he goes running headlong into a wall while trying to catch a ball.

Canon's ordinary version of auto focus depends on a subject staying as put as your grandmother wanted you to do when you were young and she was babysitting. But, as a science fiction character (no, not your grandmother) once said, "There is another." Actually, there are three:

- One-Shot AF
- AI Servo AF
- AI Focus AF

One-Shot AF is what we've discussed thus far, and it is the choice for inert objects and overly well-behaved children. In other words, it's for things that aren't moving around.

When you have to keep up with the subject, you need one of the other types. Back to the science fiction analogy, AI Servo AF means that the camera's onboard computer uses artificial intelligence to watch how something is moving and actually predict where it will go. So the camera effectively starts setting focus for where the subject will be, not where it is or has been.

AI Focus AF is a best of both worlds scenario. The camera starts off in One-Shot AF mode, assuming that the subject isn't going much of anywhere. But when that scamp of a focal point takes off like a squirrel after an acorn, the camera shifts into AI Servo AF mode as you follow it. And if the subject gets tired and stops and you no longer have to move the camera to follow, things go back into One-Shot again.

It's really impressive to follow along, finger halfway down on the shutter button, and see how the lens focus shifts with the movement. However, to appreciate that, you have to know how to change the auto focus mode, and that is going to depend on the camera model you're using. Read that manual. Then you use auto focus as you did before, with one caveat: don't forget to switch back to One-Shot mode when you're ultimately done with the action work. Otherwise AF lock doesn't work as you would expect, because the camera thinks that something is moving around, and the focus point in the image keeps shifting as you do.

Now there's just one more thing that will routinely affect the way you focus: depth of field.

My Field Is So Deep

At the beginning of this chapter, I mentioned having areas of a photograph blurred so that your eye would travel to the important parts. Although you can do that with a digital camera on your PC, the classic way is to rely not on computer science, but on physics.

When you were in school, you might have taken a magnifying glass, held it to your eye, and looked at things. You moved the lens (that's all a magnifying glass is—a big lens) back and forth until what you wanted to see looked sharp. If you looked at something else and kept the glass the same distance from your eye, you probably moved back and forth so that the new object was now in focus.

Your experience was an example of how a lens can only focus on things a specific distance away at a time. In fact, older manual cameras often had distance settings for focusing. Even though it doesn't require you to break out a tape measure, your EOS camera literally only can focus on things one distance away at any time.

So how can things at different distances in pictures look to be in focus at the same time? The answer is something called *depth of field*. All the objects within a certain range of distances from the camera will appear to be in focus even when they aren't.

Photo Pro Jargon

Depth of field means the range of distances within which objects in a picture look sharp.

It all comes down to perception. Try to focus your camera manually and you'll eventually see that the question isn't always whether you have something in absolute focus or not, but how *much* in focus it is. The human eye can only see so much detail. In fact, someone with perfect sight under good lighting can only distinguish between things that are at least a minute of arc apart. That means if you turned around 360°, you would only notice something larger than one-sixtieth of that circle. At reading distance, that means you could only distinguish between two points if they were at least a fifth of a millimeter apart. And you thought you needed reading glasses *before*.

It's just that limited ability to see detail that makes depth of field work. Look at Figure 6.3.

Figure 6.3

Objects away from the one focused on will look increasingly out of focus.

The center dot on the left of the drawing is in focus. Because the other dots are at different distances from the lens, they technically aren't in focus and their images are little circles. But if the circles are small enough, our eyes don't see the detail. Then the images still look like in-focus dots to us. That's the power of the depth of field: so long as objects are close enough to where we're focusing, they'll look sharp in the final image.

But how close is close enough? It depends. With a given camera, three factors influence that depth of field, and just what will seem to be in focus:

- The longer the focal length of the lens, the smaller the depth of field.

- The smaller the aperture, the larger the depth of field. (See Chapter 8 for more information on aperture size.)

- Depth of field is greater behind the object in focus than in front.

You can use depth of field to put certain parts of your image into sharp relief against variously blurred surroundings—a practice called selective focus (see Chapter 5 where we discuss focusing techniques). Say that you wanted to get a picture (like that in Figure 6.4) of a flower and wanted to direct the viewer's eye to a bug sitting on them and not to a distracting background. Choosing a shallow depth of field is the answer.

Figure 6.4

Objects away from the one focused on will look increasingly out of focus.

What I did was stand back (hey, I didn't want to get stung!) and use a 200mm lens with the aperture opened all the way. The combination of fairly long focal length and small aperture number gave me the effect.

Or it could be that you wanted as much as possible to be in focus. In that case, you'd use as short a focal length lens and as small an aperture as you could, as in Figure 6.5.

In this case, I used a 50mm lens at f4.0. A higher f-stop would have given me even more depth, but I already had to hold the camera still with a shutter speed of $\frac{1}{10}$ second, and I didn't want my bodily twitches to turn all that sharpness into fuzz.

Figure 6.5

Objects close and far away can look in focus.

Getting Hyperfocal

When you want to control depth of field, there's another child of physics that you need to know: the *hyperfocal distance*. It's the distance that gives you the greatest depth of field with a particular focal length lens set to a specific f-stop.

If you focus beyond the hyperfocal distance, then everything from that point on to infinity is also in focus, but you start losing depth of field in *front* of the object in focus. So the hyperfocal distance lets you plan wide depth of field shots efficiently: focus at that distance, and you literally get as much depth of field as the laws of physics will allow. On the other hand, if you want a narrow depth of field, the hyperfocal distance establishes a kind of back wall that you don't want to hit.

> **Photo Pro Jargon**
>
> Given a certain focal length lens and aperture setting, the **hyperfocal distance** is the closest distance at which everything between it and infinity will seem in focus.

Unfortunately, something this handy can be elusive. There are four ways to find the hyperfocal distance:

- ◆ Calculate it from the mathematical formula
- ◆ Use a printed reference table

◆ Use a computer program

◆ Figure it out from your lens

The first way is too much work for my taste. The second is better, though if you have a lot of lenses (or if you have a zoom lens), you could need many tables to cover all the focal lengths. If you want a program or even online calculator, try searching for "hyperfocal distance" and "calculator" on the Internet.

My preference is using higher-quality (and, unfortunately, also higher-price) lenses that virtually have the information built-in. Or built-on. Look at Figure 6.6.

Figure 6.6

Choose the f-stop of the lens and you can see what distances will be in focus.

This is an example of a lens (actually a Canon 85mm L) that has a *depth of field scale*. Marked onto the lens barrel itself, it's a center line with aperture numbers on the right and left. When you focus on

Photo Pro Jargon

A **depth of field scale** shows the depth of field of a lens.

an object at a given aperture, the matching number to the right and left of the center line match up with different values on the distance scale. Those values show the closest and farthest points that are within the depth of field.

TIFF Luck

Using the hyperfocal distance is pretty easy in practice—as long as you are in the right operating mode. You need the aperture to be constant, so plan on switching to Aperture Priority or Manual mode. (See Chapter 2 for information on both operating modes.)

Finding the hyperfocal distance this way is easy. Turn the focusing ring until the infinity sign lines up over one of the numbers representing the aperture (f-stop) you are using. The center line is now under the hyperfocal distance. All you have to do now is pick a point about that far from you, focus on it, and take the picture. Chances are one of the printed numbers won't line up, so just estimate what the value of that point on the scale would be.

See That Depth of Field

Whether you use the hyperfocal distance or not, you will still want to be able to see the effect of depth of field on your composition. That's no easier said than pushed:

◆ Decide on the visual center of your image. (If you need assistance here, refer back to Chapter 5.)

TIFF Luck

As the aperture gets smaller, the picture gets dimmer and you may not be able to see anything in the viewfinder when you press the depth-of-field button.

◆ Locate the depth-of-field button on the front left of your camera and keep a finger on it. (If you are having problems finding it, check the camera manual.)

◆ Hold the viewfinder up to your eye, compose your shot, and focus (whether manual or auto).

◆ Press the depth-of-field button.

When you push the button, the camera actually stops down the lens to the aperture without taking the picture.

Automatic Depth of Field

There's one more depth-of-field trick that the EOS cameras have up their sleeves ... or whatever it is that cameras have. It's called Automatic Depth-of-Field and it lets you point and click your way to getting what you want in focus. Here's how to use it:

1. Set the operating mode dial to A-DEP.

2. Select an AF point over the nearest part of the image that you want in focus.

3. Press the shutter button halfway down.

The AF points that light up in red show you the extent of the visual area showing in the viewfinder that will ultimately be in focus.

The Least You Need to Know

◆ Focus on the most important part of your image.

◆ Use auto focus for most things.

◆ Use manual focus when the conditions don't allow auto focus to work.

◆ Choose the most convenient AF point.

◆ AI Servo AF and AI Focus AF let auto focus work on a moving subject.

◆ Depth of field helps you direct the eyes of your audience.

Chapter 7

Decent Exposure

In This Chapter

- ◆ Getting the right amount of light
- ◆ Understanding light meters
- ◆ Choosing exposures
- ◆ Using EOS technology to expose smarter

Photography is all about the light. Without those fabulous photons racing through your lens like so many closely packed New York subway riders at rush hour, do you know what you'd have at the end of the day? Bupkis.

But it's not enough to open the floodgates and let the sun (or table lamp) shine in. Proper exposure is up there with learning to focus: without it, you can't count on taking a good shot. Sure, you could depend on the EOS's ability to determine the proper exposure. However, think about other cameras you might have used that did everything automatically. Ever get pictures where the color was washed out, or important parts were too dark, or maybe everything was so bright that you could barely see any detail?

Those problems are all a result of bad exposure. Understanding exposure and how to measure it helps prevent the terrible disappointment that can appear when you review your work in the preview window. And then you can take the next step. When you can start controlling how you use light, you move from getting what you see in front of you to capturing the image that you see in your mind. So hang in there. Although this will probably be the longest chapter (or maybe just seem that way), by the end you'll know how to bring out shadow detail and tame wild highlights. But to get there, we have to talk about how the camera works for a moment.

All Physics, All the Time

Look back at Chapter 2 to review the essentials of how an EOS digital camera works. Each pixel on Canon's imaging chip generates electricity when light hits it and stores up the resulting electrical charge. The camera then reads the charge from each pixel and converts it to a level of light (we'll ignore the whole color thing for now).

The more light that hits a pixel, the more charge the pixel creates. But there are some qualifications here. The physics involved (I said we'd ignore color, not science) say that if not enough light strikes, the pixel won't generate any electricity and you won't see anything. You can have too much light, as well. Pixels can only accumulate so much charge, after which everything gets washed out and, again, you can't see anything.

News Flash _____

Your camera translates the charge in each pixel into a number that fits into one byte of storage. That means each pixel can only take a value from 0 (completely dark) to 255 (completely lit). If the pixels in an area of the sensor are all either at 0 or 255, that area will be, respectively, all black or all white, and there won't be any detail you can see.

So you need to ensure that enough light—not too much and not too little—enters the camera to get an image. And there's another

consideration, as well: *latitude.* Latitude is an expression of contrast; the difference in the amount of light reflected by the brightest and darkest parts of something you see.

When you compare any camera system to the human eye, the camera system is going to lose out. Your eye is constantly shifting for conditions, adjusting to capture a wide range of light and dark. It also works hand in hand with your brain (or whatever set of body parts would be appropriate), which is an amazing imaging system in itself. A camera, whether digital or even traditional film, captures only a fraction of what you can see because it doesn't have the ability to make those minute adjustments.

Photo Pro Jargon

Latitude refers to the range in light intensity that a medium can recognize. In the world of digital sensors, the more technical term is **dynamic range**, but it works out to about the same thing as far as we nonpurists are concerned, so we'll use the traditional photographic term. Call it a latitude attitude.

You can actually get a sense of what this is like: drive on a brightly lit day and go into an underground garage. Notice how you're suddenly straining to see? Or go from a dark room into the noonday sun and you'll be clasping your hands over your eyes, unable to make out a thing. That's what your digital camera constantly faces: too much change and not enough time to adapt. (Wow—sounds like a bad day at work. Oh, wait … the camera *is* working.)

Practically speaking, that means if the contrast of what is before your eyes is too high, then it will expand beyond what the camera can accommodate. Suddenly you have the pixels in sections of the sensor pushed to values of either 0 or 255—respectively, either all black or all white.

Unfortunately, the world does not tailor itself to the needs of the Canon EOS cameras (or much of anything else that I've found). Don't expect little spotlights to suddenly appear from the heavens to even out the lighting. So proper exposure has several aspects:

- ◆ You don't want a blank space where you expected a picture to be.

- ◆ By understanding exposure, you can minimize the cramp that the camera's reduced latitude makes in your style.

♦ Creative use of exposure is one of the easiest ways to get special visual effects.

It may sound complex, but it's actually a lot more simple than all that. (If my simple mind can grasp it, you're bound to find it easy.)

The Great Exposure Trifecta

Even though there are trade-offs you'll learn to make in choosing an exposure, the basics are pretty simple. We'll start with the imaging troika. No, we're not speaking Russian through the topic; exposure rests on three factors:

> **Photo Pro Jargon**
>
> The **shutter speed** is how long the camera opens the shutter to expose the sensor to light from the lens. The **ISO setting** determines how readily the sensor responds to light striking it.

♦ How much light the camera lens can let in (the lens aperture)

♦ How long the shutter stays open to let light fall on the camera's sensor (the camera *shutter speed*)

♦ How sensitive the sensor is to the light (the sensor's *ISO setting*)

These three factors work together to control exposure. The following may get a bit confusing, but hang in there, because the more you know about the theory of how exposure works, the easier it will be to get the images you want. Here is how each factor works:

♦ The larger the aperture, the more light goes through the lens. Something that can throw you at first is that f-stops work backwards from how you might initially think. The smaller the actual f-stop number, the larger the aperture opening. You'll see the explanation a little later in this chapter.

♦ The faster the shutter, the less time light has to get through the shutter, and so the less light gets to the sensor. This also can get perplexing because of the way cameras often display shutter

speeds. A shutter speed of $^1\!/_{125}$ is faster than a shutter speed of $^1\!/_{60}$, so the shutter is open less time and less light gets through. However, cameras use a shorthand to avoid writing out the complete fraction, so the shutter speeds in this example are displayed as 125 and 60, respectively.

◆ The more sensitive the sensor (higher the ISO setting), the more it reacts to light. Finally, something that works the way it sounds.

The following table shows the traditional sequence of values that you'll run across using the technical terminology (f-stop, shutter speed, and ISO value) for the three factors (how much light the lens allows in, how the shutter stays open, and how sensitive the camera sensor is to light).

Common F-Stops, Shutter Speeds, and ISO Values

F-Stop	Shutter Speed (in seconds)	ISO
1	2	64
1.4	1	80
2	$^1\!/_2$	100
2.8	$^1\!/_4$	125
4	$^1\!/_8$	160
5.6	$^1\!/_{15}$	200
8	$^1\!/_{30}$	250
11	$^1\!/_{60}$	320
16	$^1\!/_{125}$	400
22	$^1\!/_{250}$	500
32	$^1\!/_{500}$	640
45	$^1\!/_{1,000}$	800
64	$^1\!/_{2,000}$	1,000
90	$^1\!/_{4,000}$	1,250
128	$^1\!/_{8,000}$	1,600

Thumbnail Tip _____

Compare your camera's shutter speed, aperture, and ISO values with those in the preceding table and you'll see that they differ. A lot. There will be only a handful of ISO choices, the f-stops may only go down to 22 or 32, and there will be a few extra shutter speeds. Don't let that shake you, as you'll have everything you need to get a good exposure.

Open the Shutter

Traditionally, shutter speeds got progressively smaller by half, so each would let in only half the light of the one before. That's because humans need to be hit over the head pretty hard before they start to notice it, and we tend to perceive things logarithmically—that is, in geometric progression. For example, the next notch on the stereo's volume control is often twice as loud as the previous one.

Notice that the shutter numbers are based on a powers-of-two system. Okay, okay, so when mentioning the powers-of-two system I lied a little. But it was a white lie of historic proportions. The shutter speeds *usually* drop by half at each step, except when they don't quite. Personally, I think it was to get the numbers to eventually come out to something round, so, for example, you'd get ¹⁄₂₀₀₀ instead of ¹⁄₂₀₄₈. Frankly, it doesn't make a whole lot of difference either way, but it's a lot easier to remember all the zeros.

Shutter speed lets you treat the movement of subjects in different ways. The faster the shutter, the more you can freeze things in their tracks. Conversely, the slower the shutter, the more action blurs, which can be a good way to indicate speed. Look at Figure 7.1 for an example of three ways to treat the same object—in this case, part of a spinning wheel that I saw at the Billings Farm & Museum in Woodstock, Vermont. (A fun place to take pictures, by the way.) The series goes from completely frozen motion to slight blurring at the edges to no distinct form at all.

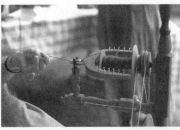

Figure 7.1

Notice the part going from frozen to blurred.

F-Stop That

F-stops—the size of the aperture—also progress so each allows in only half the light of the previous one. But the f-stop values are not as simple as the shutter speed. The numbers just plain look weird, and you'd think that they would progress along a power of two pattern because the amount of light drops by a half each time.

They actually do, only, the f-stop doubles *every other* time. There's a reason: each f-stop is actually a ratio between the width (diameter) of the aperture and the focal length of the lens. The area of the aperture—and, thus, the amount of light that can get in—depends directly on the square of its radius, which is half of the diameter.

Check back in Chapter 6 to see an example of selective depth of field, which you accomplish by using different f-stops.

News Flash _____

You can actually determine the area of a lens's aperture by dividing its focal length by the f-stop. That's why less light gets in as the f-stop gets *higher:* you're dividing the focal length, which doesn't change, by a bigger number to get a smaller aperture diameter and, therefore, a smaller area. See? Told you there would be an explanation.

I won't go through all the steps a complete discussion needs (though I can't stop the mathematically adventurous). But trust that as you go from one f-stop to the next highest, you change the area of the aperture by a factor of two. In fact, if you have a phobia of numbers, skip the brief explanation in the next paragraph. You don't need to understand it to make use of f-stops.

If you're reading on, though, you must be determined to see some kind of rationalization, so here it is. Basic geometry and math say that the area of a circle is directly proportionate to the square of the circle's radius and diameter (the latter being twice the radius). If you cut the aperture in half, you've divided the radius by two—or multiplied it by $\frac{1}{2}$. But the area changes by the square of the radius (the radius multiplied by itself). Because the new radius is really $\frac{r}{2}$, when you square it, you get r squared divided by 4. As the area is a fourth of what it used to be, it only lets through one fourth the amount of light as it did.

Back to earth. Here's all you need to know: make the f-stop two values bigger (like going from f/2.8 to f/5.6) and you've decreased the aperture area—and the amount of light it can pass—by four.

Notice, too, that I lied again. Even the f-stop numbers are a bit off. If they double every other value, you might expect f/11.2 rather than f/11, or f/5.5 instead of f/5.6. But you don't. I guess once the people who created the f-stop scale got into the double digits, they started saying, "Decimals? We don't need no stinkin' decimals."

In Search Of (ISO) Sensitivity

Tired of the power of two? Well you can forget it, at least for a moment, because now we're talking about ISO values. I could go into the entire history of how these numbers came about, but I'd probably fall asleep and you'd have nothing but blank pages in the rest of this book.

When it comes to specifying the sensitivity of the sensor, what you should remember is that ISO is completely linear. That means if you use the camera's controls to move the ISO value from 200 to 400, you've just doubled the sensitivity.

TIFF Luck

Although your camera does have a range of ISO settings, the lower ones are the best to use. Starting with 800, the image qual-ity can start falling off because the camera is amplifying the signal it gets from the sensor. Amplification means making **noise,** or the small unintentional interfering signals that appear in any electronic device, more obvious. To see the effect, take a picture of something at ISO 100, then select the highest ISO rating your camera offers and take the picture again, and then compare the two on your computer screen.

So now you have three collections of numbers. How exciting. Okay, maybe not. But somehow you have to decide on which combination of shutter speed, aperture, and ISO is going to work best. It seems like a lot of trading off, but actually it's much easier than you think.

Exposing Yourself (Or at Least Your Camera)

Getting the right exposure actually means letting enough light strike the sensor so you get as close as possible to the image you want. Often that means getting a nice clear picture of something, but it can also mean capturing a certain mood that you sense but that may not be obvious at first glace. Here's the basic procedure for setting exposure:

1. Choose an ISO setting appropriate for the conditions.

2. Use a meter to set the overall exposure.

3. Decide what changes to make, if any, based on the contrast of the image and what you want to emphasize.

4. Pick a combination of shutter speed and aperture to get the effect you want.

Sound easy? It is. We'll start with the first step.

Setting the Sensitivity

Picking the right ISO setting is a matter of educated guesswork. That's what I call having made so many mistakes over the years that I sometimes get it right. In general, the less light there is overall, the higher an ISO setting you will need, though sometimes you trade off more sensitivity so you can get something in return, like the ability to use a faster shutter speed so you can capture the action at a sporting event.

But you probably don't want to spend years getting a sense of where to start in setting the ISO value, right? I didn't think so. Well, I guess we can look at the following table for a moment.

Typical Uses of ISO Values

ISO Value	Conditions
100	Daylight or inside with a flash
200	Daylight, overcast, or flash
400	Daylight, overcast, flash, action
800	Low light, fast action
1,600/3,200	Very low light, very fast action

The table is just a rule of thumb. The real test is setting the ISO value, determining the exposure by metering, and then seeing if the aperture and shutter speeds you'd have to use are practical choices (and we'll get to that in just a bit). But you can always change the ISO value and then go back again to setting the exposure. To actually set the ISO value, do the following:

TIFF Luck

If you've got the camera in any of the basic modes (see Chapter 2 for the operating modes), you can try setting the ISO speed from now until the cows come home. It won't matter because when the camera is running in one of the fully automatic modes, it does what it thinks it should, not what you think it should.

1. Press the ISO speed set button.

2. Use the appropriate selector buttons or dial to choose the value you want.

3. If your camera calls for it, press the Set button.

The location of the controls and the details of where you can see the ISO speed depends on the model EOS camera you have. Check your manual.

A Gray Outlook

After you have decided on an ISO value, you put it into a *light meter* that will determine how much light is needed to get a proper exposure. Whether the meter is built into the camera or an external unit that a photographer might use for a real manual approach, there's one characteristic you will find. A light meter, whether in a camera or in your hand, is dumb. Really dumb. A meter just looks at a scene and says, "Yup, I see this much light coming in— guess I'll tell them to set the exposure this way. <Yawn> All this work is making me sleepy."

Photo Pro Jargon

A **light meter** is a device that measures light and indicates how to properly expose an image.

The meter thinks that everything is supposed to be gray—an 18 percent shade of gray, to be exact, which Figure 7.2 shows. How dull. No wonder the meter nods off. The reason for the simple-minded approach is practical. The meter is just a light-sensitive chip, like an ancestor of the digital camera's own image sensor. It doesn't know highlights from shadows and has never heard of contrast or dynamic range.

Figure 7.2

It's not all Greek to a light meter—it's all gray.

News Flash

A regular light meter takes one reading for an entire area, but there are special types of light meters. For example, a **spot meter** lets you aim through a viewfinder to take a reading on a small portion of the scene in front of you.

When you push the shutter button halfway, your camera's meter wakes up and, seeing there's no coffee, decides that some work would be in order. Depending on the mode you've set the camera, the camera will do one of three things:

◆ Decide on both an aperture and shutter speed

◆ Let you set either the aperture *or* the shutter speed while it determines the corresponding other value

◆ Let you set both the aperture *and* the shutter speed, telling you when a given combination will give you the right exposure

All the meter figures out is, given an ISO setting, what combinations of aperture and shutter speed will correctly render that 18 percent gray. Because that shade is actually right in the middle of our visual range, more often than not the rest of the image falls into place and everything is correctly exposed.

Thumbnail Tip

You'll see that more than one combination of aperture and shutter speed will give the same exposure. This is where the powers of two come back in. Look back at the preceding table on ISO values. Each increase by an f-stop or decrease by a shutter speed cuts the light by half, and vice versa. So if you increase one f-stop and decrease one shutter speed, or if you decrease one f-stop and increase one shutter speed, you still have the same amount of light.

When Correct Isn't Correct

"More often than not" leaves lots of room for things to go wrong. There are conditions that confuse a meter. For example, say you're trying to take a picture of someone whose back is to the sun. The face reflects light toward the camera and meter and is probably near a middle gray—maybe a little lighter, maybe a little darker. But the sun is incredibly bright, throwing off a lot of light that can overwhelm the light reflected off the face and trick the meter into underexposing the image.

It could be that the contrast in what you are looking at is wider than the camera can handle. As a result, you might not be able to get both

the highlights and the shadows and might have to choose one or the other. Or you might want to be artistic, "seeing" something different than what sits in front of you. (I often see images darker than they appear to be. That suggests that either I have a troubled psyche or that I really need new glasses.) In any case, slightly different exposures can make a big difference with a digital camera, as Figure 7.3 shows.

Figure 7.3

The bottom image was exposed right after the top at f/2.8, but at $^1/_{500}$ of a second instead of $^1/_{250}$.

In other words, there are times that you will need to change the exposure. You can control the exposure manually, or you can have the system do the work for you. Right, there's only one choice, and you push the work off onto the shoulders of your camera by setting the exposure compensation:

1. Choose an operating mode that isn't completely automatic or manual. (See Chapter 2 and your camera's manual if you need a refresher.)

Photo Pro Jargon

A **stop** is a change to the metered exposure equivalent to a full f-stop or shutter speed.

2. Press the shutter button halfway. You'll see an exposure level indicator in the viewfinder. (Check your camera model's manual to see where in the viewfinder it is.)

3. Turn whatever dial changes the exposure compensation. You can increase or decrease the exposure by up to 2 *stops*.

Now you can use the camera and the meter will automatically increase or reduce the amount of light that gets to the camera's sensor. Now you have an exposure to work with—and if the results aren't what you want, you can change the exposure and try again.

Pick Your Take

Now that you have an exposure, it's time to decide how you want to get it. This is where you consider issues of depth of field and whether you want or need to stop action. If you've picked one of the EOS basic zone modes—the ones that give you fully automatic shooting—then there are no choices to make.

But if you choose one of the creative zone modes (other than manual), you can change the aperture and shutter speed pairings easily:

1. Look in the viewfinder, press the shutter button halfway, and then let it go.

2. Watch the bottom of the viewfinder and turn the main dial. The aperture and shutter speeds will change while maintaining the exposure you set.

3. When you see what you want, stop turning the dial and press that shutter button quick before everything starts moving, upsetting your artistic inspiration and aspiration.

If you're in manual mode, then you're largely on your own. Check the camera's manual to see how to change the aperture and shutter speeds. Remember that if you change one, you'll have to change the other to maintain the correct exposure.

TIFF Luck _____

In your photographic reverie, it's easy to spin the dial so much that you either run out of aperture or shutter speed values. If you take your picture then, you'll ruin it. (I know I have.) Keep aware of what the readouts at the bottom of the viewfinder say. If you find something starting to blink, or if something goes to a value and sticks there, then back up.

There will be times that no matter how you try, you won't get the shutter speed or aperture value that you want. You have two paths open to you. One is to go back and change the ISO speed to another value. As you change the sensitivity of the sensor, you change the ranges of shutter speed and aperture that will give you the exposure you need. Here's a strategy:

◆ If you need a smaller aperture (bigger f-stop) or faster shutter speed, increase the ISO value.

◆ If you need a larger aperture (smaller f-stop) or slower shutter speed, decrease the ISO value.

Experiment with the different operating modes and see which approach to exposure ones you gravitate to. If you're anything like me, you'll probably find one or two that just feel natural based on the way you see and what you like to photograph.

Thumbnail Tip _____

If you're using either the Av (aperture priority) or Tv (shutter priority), don't think you're stuck looking at exposure only one way. I typically set my equipment to Av because I'm primarily interested in depth of field. But if I need to concentrate on the shutter speed first, I still can without shifting modes; I just spin the selector wheel, going through different f-stops until I see the shutter speed I want.

Exposure Escapades

There are tricks that can make exposure easier to calculate and check. Here are three of the main ones that your camera can help you with:

◆ *Metering mode*

◆ *Bracketing*

◆ *Histograms*

Photo Pro Jargon

The **metering mode** is the type of automatic exposure metering you tell the camera to do. **Bracketing** is the practice of taking a few shots, some with greater exposure and some with less, in the hopes that at times an honest mistake will pull things through when knowledge and experience do diddly. **Histograms** are little graphs that show whether your exposure is right or not.

Keep your camera manual handy for the next few minutes, because it will help you locate the proper controls. Why make the process of pushing work onto something else any more taxing?

Metering Mode

Earlier in the chapter, I mentioned that there are different types of meters. The EOS cameras actually have four types of metering built-in:

◆ *Evaluative*

◆ *Partial*

◆ Spot

◆ *Center-weighted average*

In evaluative metering, the camera splits the scene up into a bunch of areas, the number depending on the camera model. It assumes that the auto focus point is on the subject, and then compares all the readings, trying to come up with a compromise.

Partial metering is kind of like a spot meter, in that it focuses on the very center of the image. But partial metering looks at just under 10 percent of the frame, while a real spot meter might focus on about 2 percent to 3 percent. It's intended to use when the subject is in the center of the frame and there is a significant difference in lighting on the subject and everything else.

Photo Pro Jargon

Evaluative metering takes separate readings over parts of the entire image. In **partial** metering, the camera looks at the exposure of the very center of the image. **Center-weighted average** is a compromise, counting the center most, but also averaging in readings from elsewhere in the viewfinder.

As mentioned, a spot meter looks at a small area of the image and calculates exposure for that area, or spot. It has nothing to do with my tendency to alternate between shooting and snacking, resulting in unintentional decorative touches to my clothing. This is my preferred approach—the metering, not the eating. I'll take a reading off something I judge to be equivalent to an 18 percent gray, shift the exposure with exposure compensation to something that I think will work, and then trip the shutter.

TIFF Luck

Although there are four types of metering modes, not all the cameras have every type. For example, a Rebel XT doesn't have spot metering.

Center-weighted average gives most credence to the lighting in the center of the frame but still averages in readings from other parts of the image.

Your camera manual will show you where the metering mode displays and how to switch from one to the other. But which one to use where, that's the question. There are a few principles:

◆ Evaluative is for most situations.

◆ Use partial or spot when there is strong contrast between your subject and its surroundings and you don't care whether the surroundings are easily seen.

♦ Center-weighted is good in high-contrast situations when you want to see the surroundings as well as possible.

But the best suggestion I can make is to experiment with them, see the results, and find how they work. Then you can decide how they work best for you. Start with evaluative and then try taking the same image with other types, seeing how the exposures differ.

Bracketing, or Exposure by Chance

When you see glorious pictures in magazines, it's easy to think the pros have secrets that you don't know, and it's true. Here's a big one: if you take extra pictures using different degrees of exposure, one of the shots is bound to turn out right.

Oh, how anti-climactic and disillusioning. But sometimes what seems to be the right exposure yields a bad photo. Cover your bases, or something, with extra shots. Take some with more exposure and some with less, and you're bound to end up with something good.

Once again, your EOS camera can pretty much do the job for you with automatic exposure bracketing (AEB). When you set it up, the camera automatically sets up to take three pictures: one at the exposure you set, one with less exposure, and one with more exposure.

TIFF Luck

Keep in mind that AEB uses the drive mode you've selected. So if you're on single shot mode, you'll have to press the button three times. If you're on continuous mode, the camera will take the three shots in succession. So you still have to show up. Oh, and if you're using flash, AEB won't work at all.

You can choose how much of a difference in exposure the camera uses, up to two stops total. Look at your camera manual to see how to select the bracketing amount, which turns on the feature.

When you're done with the AEB feature, you can turn it off in a number of ways. One is to reset the AEB bracket amount to zero stops. But it also turns off if you turn off the camera, change lenses, or use flash. Some features know when they're not wanted.

Histograms

Here's your third secret weapon: the histogram. One advantage of digital photography is the ability to see your results without waiting to get film back from the lab. But while you can review your images on your camera's LCD—and it's a good idea, as you'll see in Chapter 8—you can't get a completely accurate idea of how accurate the exposure is.

That's why the EOS cameras have the histogram feature. The mechanics are easy, though they differ among the models, so check your manual. What's important is what these funny little graphs show. Each one is like a picture of a picture. It shows how the image's visual tones are distributed from dark to light. Look at Figure 7.4.

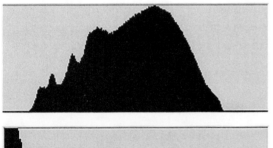

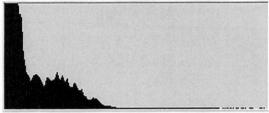

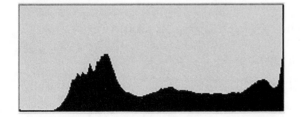

Figure 7.4

The top graph is of a normal exposure. The middle one is dark and the bottom one is light.

The histogram at the top shows a normal exposure, with tones pretty evenly distributed from left (dark) to right (light). The second one down is from a dark picture, and the third is a light picture. Notice how the

middle and bottom graphs seem to run off the edge of the displays? In the dark image, that means you are losing detail in solid black areas. The bottom graph has lost detail in totally washed out highlights.

Yes, you knew it—it's graphic insight into the quality of your images. And if the histogram is pushed too far to one side or the other, you can fix things:

- If it's to the left, you need to increase exposure.

- If it's to the right, you need to decrease exposure.

If you need to change the exposure, you've got a few choices. Try a different way of metering, focused on another part of the image. Use the exposure compensation feature. Or, if things are really bad, set the operating mode to manual, find the "correct" exposure, and then change the aperture or shutter speed to change things. Yes, manual. Yes, it's that four-letter word: w-o-r-k. Don't worry, we'll try to keep that to a minimum.

The Least You Need to Know

- Choose an ISO speed value that you think will be a match.

- Pick operating and metering mode and let the camera figure the exposure.

- Adjust exposure compensation if necessary.

- If using a creative zone mode, choose an aperture and shutter speed.

- Look at the histogram to see if the image is properly exposed.

Chapter 8

Pressing the Button

In This Chapter

- ◆ Juggling latency and burst rate
- ◆ Zooming and panning
- ◆ Getting rid of the junk

In my formative years—just so you know whom to blame—I watched a movie called *The Great Race*. In this Blake Edwards comedy about an early twentieth century auto race across three continents, bad guy Professor Fate, played by Jack Lemmon, directs henchman Peter Falk to set off a dirty trick. "Push the button, Max!" he screams.

Sometimes at odd times with my camera, my right index finger hovers over the shutter button, and suddenly I hear Jack Lemmon urging me on. Now, I never worked with Jack Lemmon. I didn't know Jack Lemmon. So I'm pretty certain that I'm not Jack Lemmon. But even so, you've composed your image, focused, calculated the exposure, and now I say to you, "Push the button, Max."

That would be fine, except you aren't Max and taking the picture is a bit more than just pushing that button. It's like the

follow-through in your tennis swing. (You may not play tennis either, but that's neither here nor there.) Shutter buttons don't necessarily work as fast as you'd think, and taking a good picture doesn't end with the click of the mirror and shutter. And we're going to learn what it entails before it's too late.

We're Late ... We're Late ... For an Important Photo Date

There's an irony in digital photography: it's the realm of instant gratification, but you have to wait for it. When you finally push that shutter button, things might not happen as instantly as you'd like. There are four possible causes:

- the camera powered down
- *latency*
- the *drive mode*
- image writing

Photo Pro Jargon

Latency is the time lag between when you press the shutter button and the shutter opens. **Drive mode** is the EOS feature that lets you go from single images to continuous shots so long as you keep the shutter button pressed.

You have to know about these things so you can actually get the picture you've just been doing all that work to get. It's irritating (at least) to press the shutter button and watch that perfect picture come and go while you wait for the shutter to work.

Waking Up the Camera

I swear, digital cameras can be lazier than I am. Seriously, they power down when you're not taking pictures so they can conserve power and not go through battery charges like potato chips at a picnic. But after they've shut down waiting, it takes some time to get them going again.

The amount of time varies by the EOS model. I've found it taking seconds with my 10D. (Yup, an older model. Hey, I paid for it, it works great, so I'm gonna keep using it.) Remember to press the shutter button halfway *before* you need to take that shot.

Thumbnail Tip _____

When you're trying to catch fleeting moments (is there some greeting card commercial in the works?), you can periodically press the shutter button halfway to keep the camera alert and ready to work. It uses extra power, but what else are rechargeable batteries for?

Latent Images

Not only is there a delay when that power-frugal camera shuts down, but in any SLR—digital or film—there's always a lag between when you push the button and when the camera actually takes the picture because of latency. Look at Figure 8.1 and think about everything the poor camera has to do when you push the shutter button. First the lens stops down to the aperture you plan on using (it stays open for a brighter image so you can see what's going on). Then the mirror has to swing up out of the way. Finally the shutter gets to open.

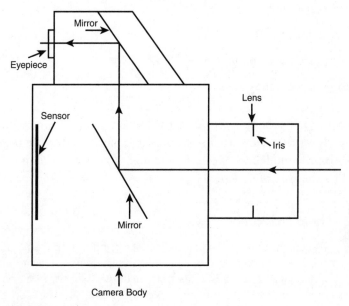

Figure 8.1

Sure, it's digital—and mechanical.

Camera manufacturers have had decades to work on getting the snap into snapping a picture, and the delay is only going to be a fraction of a second. But when you want to capture something fleeting—the first steps of a child, an unbelievable catch on a ball field, or the shortest moment of all, a spell of quiet common sense on political talk shows—that can be enough.

After using your camera for a while, you can get a feeling for latency and avoid some wait and see. Try to anticipate moments and "take the picture" right before what you want to capture happens. It doesn't always work, but it's worth the experimentation, and the more you practice, the better you can time it.

Drive Down the Wait

Do you find that you want to keep jabbing the shutter button to take pictures faster? Whoa, slow down. There's only so quickly the EOS can open and close its shutter and flap that mirror. If you're in a hurry, you might consider changing the drive mode. More modes? Yup. This one has up to three choices:

◆ Single shot

◆ Low speed continuous

◆ High speed continuous

In the continuous modes, you press the button and the camera starts ripping. How fast each of them can take one picture after the next depends on the model, so check the manual. You're also going to be limited by the *maximum burst*.

Photo Pro Jargon _____

Maximum burst is the largest number of photos the camera can take before it has to wait until it has written images out of its built-in memory and onto the compact flash (CF) card you put in. The actual number depends on the size of image file you choose (see Chapter 9 for discussion of image file types and sizes), the type of CF card you use, as well as other factors.

Continuous shooting mode does offer a way around dealing with latency. Instead of trying to trip the shutter just before the moment you want, use one of the continuous modes and start a second or two before and keep going until just after. Chances are that at least one of the shots will have what you want.

TIFF Luck

Canon calculates the top shooting speed rating under pretty ideal conditions. The actual number of photos you'll be able to take per second will depend on a lot of factors, including the ISO speed setting, the shooting mode, whether you're using bracketing or not, and even the AF mode you choose. Also, not all the EOS DSLRs have all three choices, so depending on the model you own, you may only have one type of continuous.

Waiting for That Image Transfer

I thought writing a book was slow going until the first time I found myself waiting for my camera to write images out to the CF card. Well, maybe writing a book does take more time, but when you're hovering over the progress indicator on the camera, it doesn't seem like it.

The problem is that the camera has only so much memory built in. To make room for new pictures, it has to transfer the ones you've already taken to the CF card, and that takes time. Your waiting isn't theoretical. If things get too backed up, you may not be able to take a picture until at least one of the images gets written out.

It may be my style of shooting—more picking and choosing rather than going through machine gun-like runs of shutter clicking that might be necessary in situations like sports photography—but so far I haven't been kept from taking another picture. What I have seen, though, is that when the camera is writing to the card, there's no access to the card to preview images on the camera's LCD screen on the back. There's absolutely nothing you can do about this but wait—and, maybe, stop taking pictures for a minute so you don't keep adding to the pile.

News Flash _____

Makers of memory for digital cameras have been falling all over themselves, and each other, creating "professional" versions of their products, including CF cards. The pro models can transfer data faster than the normal ones, meaning that the images get off the camera and onto the card more quickly, so you have a shorter wait to take more pictures or review the ones you've already taken. (Chapter 9 has more on CF cards.)

Reviewing Those Masterpieces

You don't stop taking the picture just because you pressed the shutter. Since you have a digital camera, you might as well look over the pictures you just took. Aside from stroking your own ego—Oh, my, what wonderful artistry!—there are some practical reasons to periodically look at what you have. These include ...

◆ Check exposure and focus.

◆ Make sure you have the pictures you wanted.

◆ Do a first round of image editing, tossing the ones that don't make the grade.

But to do that, you have to navigate through those images. This is another time to thoroughly check the camera manual, because the controls for doing everything vary among the EOS models.

Thumbnail Tip _____

You can set the camera to automatically display images for a set amount of time after you take them. However, I personally turn it off. I've found that the automatic display is distracting, as I keep going to the screen instead of looking up at my subject, and the display can take up time and power unnecessarily. Instead, I just press the image preview button when I want to take a look and then scroll through the images in batches. However, I do set auto image rotation, which will rotate images by 90° when I've turned the camera on its side to get a vertical shot. Also I'll set the image display brightness so I see things comfortably without using too bright a display (and extra power consumption) to get visibility.

Look at the directions and get familiar with how to do the following (I'll use my transcendental patience, developed while waiting for images to write to the CF card):

◆ Turn on image display.

◆ Bring up the thumbnail display.

◆ Choose an image from the thumbnails.

◆ Magnify the image.

◆ Scroll through the image.

Oh, sorry, are you done already? Then let's look at a good way to review images after you've taken some shots and can work in a break:

1. Turn on image review.

2. Look at the LCD screen, bring up the thumbnail display, and choose an image to review.

3. See if the image seems to be extremely under- or overexposed.

TIFF Luck

Although handy, the LCD screen is like a friend—ask for critical insight and you may get a flattering response. I've often noticed that images that seem well exposed on the camera's LCD are underexposed when I examine them in Photoshop on my PC. If you find some kind of systematic discrepancy, go to exposure compensation (see Chapter 7) and change the exposures accordingly.

4. Magnify the image—a lot.

5. Scroll through the image from side to side and top to bottom to find fine details that should be in focus. See if they are.

Thumbnail Tip

When you magnify an image on the LCD, you'll notice a little gray rectangle with a smaller white rectangle inside in the lower right corner. The white rectangle represents the magnified area and the gray is the whole image frame, so you can see where in the whole image you are.

After doing all this with at least your critical shots, you'll be able to tell while you're still near your subjects whether you can rest with what you have, or if another round of picture taking is going to be necessary. "Wait, Johnny, can you fall into the pool again? You were a little blurry around the edges."

The Least You Need to Know

◆ Learn to anticipate shots to overcome DSLR latency.

◆ Use a continuous shooting mode to get your image when timing is critical.

◆ Occasionally press the shutter button halfway so the camera doesn't power down at times you want it ready.

◆ Review critical images on the LCD under magnification to see if they are fuzzy, then you'll know when to shoot replacements.

Chapter 9

Change That Digital Film

In This Chapter

- ◆ Choosing the file type
- ◆ Changing color space
- ◆ Setting image quality
- ◆ Picking storage media

Back in the day—you know, a few years ago—real photographers still used those celluloid strips. They'd dunk them into noxious chemicals and then transfer the resulting images to pieces of paper, or even mount little squares into cardboard frames and create "slides." How last century.

One thing they realized, though, was that different films had different characteristics. Some offered better quality images. They all differed in the range and balance of colors they showed—especially the black and white ones. By experimenting with different films, the photographers found the sets of characteristics that best served what they were trying to do.

As with virtually everything else in photography, there are digital counterparts. From selecting different file types when trading off between size and image quality to manipulating color rendition and image sharpness, you have lots of ways to influence the quality of your images. This chapter shows you how.

The Raw Deal

Ever give any thought to how your camera digitally stores visual images? They're not just treating them like tax receipts, stuffing them away in a shoebox. No, all that information goes neatly into a file so you can do things like view the picture on a monitor or print it out.

But there are filing systems and there are filing systems—and there are files, and there are files. There are standard types such as *TIFFs* and *JPEGs*. The reason you need standard files is so you can have some guarantee that the shots you take will display right on a monitor or print out in a way that's recognizable and doesn't make you wonder if your camera took up cubism. Can you imagine the chaos if every camera maker used its own system for storing images? Well, actually, they do—a format called *RAW*.

Photo Pro Jargon _____

> **TIFF,** tagged image file format, is an industry standard that stores all the information of an image. **JPEG,** developed by the Joint Photographic Experts Group (hence the name), stores an image with lossy compression, meaning it tosses some information to take up less space. JPEGs can have different amounts of compression. Camera manufacturers like Canon use their own **RAW** formats to store all the image information in a compact format.

Before things get too crazed, let's stop for a moment. There are other image formats, but they aren't important, at least for what we're doing. All three of these—JPEG, TIFF, RAW—can play a part in using your EOS camera and then doing things with the images.

Raw

We start with RAW, the native format of the camera. RAW files are like the digital equivalent of negatives, holding the raw output (get it?) of the camera's sensor. But remember that sensor only captures light at individual pixels. In other words, this is the photographic equivalent of the painting technique called pointillism.

But what about the areas between pixels? Like other digital cameras, the EOS line handles the in-between spots with image processing. A powerful chip built into the camera uses incredibly complex mathematics to fill in all those blank areas. That's why the RAW files have as much information as TIFFs but are only a fraction of the size. The extra size of the TIFF is to hold all the extra calculated points. That means RAW files are an efficient way to store all the image information—every color, every detail that the camera captures.

News Flash

If RAW files are so efficient, why don't computers use them instead of other types? Because the RAW files are all proprietary, and computers work best with standards that work with everything, including editing software and photo printers. TIFFs provide the same quality of image and are directly supported by virtually everything involved with imaging. Well, other than the cameras.

JPEG

You can also set your camera to capture images as JPEGs. The advantage is that the files are a fraction of the size of the RAWs and so you can fit more onto a CF card. You can also choose one of six different JPEG settings—small, medium, or large, each with a choice of low or high compression. The more compression, the smaller the size, but also the more information that is missing. (Canon refers to low compression as fine quality and high compression as normal quality.) Look at Figure 9.1 for a comparison. I took all three versions at different JPEG sizes, then resized them all to the same size (that comes in Chapter 16), so you can see how quality drops with JPEG size.

Figure 9.1

The images are the three JPEG sizes (large, medium, and small left to right) at low compression on a Canon EOS 10D.

News Flash

EOS cameras will let you record RAW and JPEG versions of the same image at one time. Some models will allow only RAW and large low compression JPEG together, others will let you combine RAW with any of the JPEG versions the camera supports. Check your manual (what else did you expect?) to see what choices you have. You'll also see a table showing how much storage in megabytes each file type and each possible combination typically requires.

Choosing the Format

So what file do you use? Decisions, decisions. My suggestion is in general stick with RAW only when the photos are on the camera. Here's why:

◆ It doesn't use lossy compression, and you keep every bit of detail that the camera could capture.

◆ When you transfer files to your PC, you can generate either JPEGs (or even TIFFs) whenever you need them.

◆ Although the files are several times larger than the large low-compression JPEGs, storage in the form of CF cards is pretty cheap.

JPEGs used to have two strong advantages. One was size, though falling CF card prices has eliminated that. The other was that at one time, the image editing software for computers didn't handle RAW files all that well. But those days are over as well, and many of the applications will let you open RAW files and create either TIFFs or JPEGs.

There is still one time that capturing JPEGs on the camera proves worthwhile. If you want the convenience of files that you can easily share with others and you don't want to spend time even running bulk conversions on a group of files, this will let you follow the Path of the Lazy Person. But you will need more storage room, so figure on fewer images on each CF card.

Sizing the File

For those who do plan to shoot using JPEGs anyway and forget RAW (bet you ignored mom's advice, too), it helps to know how big a high quality print you can expect. The following table should be useful.

JPEG Sizes and Print Sizes

JPEG Size (pixels)	Print Size (inches)	U.S. Paper Size (inches)
4992×3328	16.6×11.1	11×17
3600×2400	12×8	8.5×14
3504×2336	11.7×7.8	8.5×11
3456×2304	11.5×7.7	8.5×11
3072×2048	10.25×6.8	7.5×10
2544×1696	8.5×5.5	6×8
2496×1664	8.3×5.5	6×8
2048×1360	6.8×4.5	4×6
1728×1152	5.8×3.8	3×5
1536×1024	5.1×3.4	3×5

You'll have to check your manual to see which JPEG sizes the camera supports. Notice that I'm not differentiating between the lower and higher compression levels. That's because the pixel count remains the same. It's just that some of the pixels might not be exactly what they

were before being crushed like the heart of the goofy teenage boy who asked the head cheerleader out. The image won't be what it was before the compression. Love and photography can be brutal.

In addition, the image sizes in inches depend on an assumption that you would be printing them at 300 *dpi*. The term *dpi* is short for dots per inch. It's a printing term, similar to the computer term *ppi*, or pixels per inch—how many pixels a display has per inch. As you might gather, there's some room to juggle, and there are ways you can actually get a bigger (though not better) print. We'll learn how to make pictures bigger in Chapter 14. For now, bigger is better, and 300 dpi is just about right. Anyway, we have other things to monkey with.

> **Photo Pro Jargon**
>
> The term **dpi** stands for dots per inch and indicates the resolution of a printed image; **ppi** is pixels per inch, a computer term for how many pixels a display has per inch.

Fiddle with Those Files

Not only can you choose the type of file, but Canon gives you control over how the camera takes the picture. From our previous descriptions, it might sound as though the image went through the lens, onto the sensor, and then directly into the camera's memory. I fibbed: I left out a step.

When you press the shutter button and the sensor captures the picture, if you'll remember Chapter 2, it passes all the data to the amplifier, which boosts the signal to achieve whatever ISO speed rating you've set, and then to the digital signal processor. This last enterprising little device takes the electrical charges its received, does all the calculations to fill in the image between the pixels, and comes up with the JPEG formats if necessary.

But when the DSP (Canon calls the family of chips DIGIC image processors) starts making its calculations, all it knows is that the pixels are claiming certain amounts of light. It can make three types of assumptions:

irectional Lighting

ghting can help create a mood or direct the eye. (Chapter 11)

though this is a virtually monotonic image, the lighting from below, above, and hind adds contrast and shadow.

ight from the back can help create a warm halo and also, for people with brown or lack hair, help separate them from a dark background.

Composition

A little repositioning and new framing can make an enormous difference in wheth[e]r a picture works or not. My positioning for the left and right shots varied only by a few feet—and waiting for the sheep to turn my way. (Chapter 5)

Cropping

The essence of turning an acceptable photo into a good one, as in so many other endeavors, is to get rid of everything unnecessary. (Chapter 14)

larging

u say you want that picture bigger? Here you go. (Chapter 14)

cropped down the first shot to a tiny portion in the same proportions and then
nlarged it to the same print size, at 300 dpi, as the original.

Exposure Compensation

You can adjust exposure compensation in software and not just in the camera. The effect is the same. (Chapter 7)

Remember our Maine vacation? Here's that shot of the trees unchanged and then with the exposure boosted by the equivalent of 1 f-stop.

Exposure Balancing

Compare this with the before shot on the previous page. This is the difference between straight exposure compensation and actually changing exposure levels. I actually used exposure curves to boost the parts I wanted brighter without sacrificing the shadow details. (Chapter 14)

Color Adjustment

Photography isn't just about seeing exactly what was there, but in showing what you saw in your mind. Sometimes rebalancing the color is exactly what you need to do. And don't feel guilty—remember, the camera and computer can't see what your eye can anyway.

Another shot of Maine—and what do you mean you don't remember it? Some people In this case, the photo at the top wasn't either how I remembered the sunset over th lake or how I *wanted* to remember it.

Noise Reduction

quiet down there. When you've got the ISO speed cranked up to catch the ambient light, you can get a lot of digital noise. The photo looks so much nicer after you get rid of it.

Shot at high ISO in low light, then worked to take some of the noise out.

Unsharp Masking

When you have edges, you might want to sharpen them, as digital images can be a bit soft. Use some unsharp masking (or take the automatic sharpening easy way out if you must) to get a little extra definition.

Sometimes it takes just a little sharpening to get the improvement you want.

Special Effects

Here's a bonus: ACDSee has loads of effects you can apply to get different looks from your photos. In this example I took another landscape from Maine (Oh, when will he stop going on about one state?), clicked the Edit Image button, then clicked Effects, chose Oil Painting, and then fooled around with the settings. Go ahead—it's fun time now.

Sometimes it takes just a little meddling to get what you wanted but didn't know until you saw it.

- The exact color quality of the light its recording

- How much contrast to show

- Whether to artificially sharpen the image

What does all that mean? Glad you asked, because you can choose to tell that chip how to do its job.

A Little Color Commentary

Color is important when you look at something. Tones, for example, can create atmospheres, emotions, and moods, or the proper use of color can be elements that establish the image's composition.

Back in those good old days (time for an obligatory sentimental pause), photographers chose color film carefully because one product would render an image differently from another.

These days (time for a post-modernist reflective moment), you can directly control how your EOS camera handles:

- Color space

- White balance

- Saturation

- Color tone

News Flash

Not only do you have refined control over color, but, like all the other image adjustments, you can change things for a single shot.

But you've got some big advantages over those good old days. You can tweak the settings (using the directions in your manual) to satisfy your taste.

Spaced Out Colors, Man

Remember when you were a kid and it was time to get crayons? Everyone who was anyone wanted as big a collection as possible—at least the 64 color box if not the pantheon of patina: 128 individually-formulated and named colors in one box.

Certainly there was ego and status involved, but also some practicality. The more colors, the more choices you had in rendering your artistic vision. (Also, the more crayons there were to break, to grind into carpets, and to otherwise innovate your artistic "process.") Two different sets of crayons might turn the same scribbling impulses into completely different results because the colors were different.

Keep that in mind and you'll understand *color spaces*. Every single thing in imaging—from your eye to your camera and monitor and down to a printer—sees color differently. The human eye can see the biggest number of colors. But not even the best digital cameras can match it. And you also want some compatibility between how the camera, image editors, and printers handle color. Otherwise you might find that your colors either seem washed out or overly-hyped, like the latest Hollywood pigment blockbuster.

Photo Pro Jargon

A **color space** is the collection of colors that something—whether a human eye or some kind of electronic device—can see. **RGB** stands for red green blue. Personal computers represent all colors with an appropriate mix of these three colors. **Adobe RGB** (often called Adobe RGB 98) is the native color space of Adobe Photoshop; **sRGB** stands for standard RGB, a color space that many devices support.

The two most commonly used color spaces in digital photography these days are *Adobe RGB* and *sRGB*. The *RGB* part refers to how computers make all colors out of combinations of red, green, and blue. But the beginning makes all the difference:

- Adobe RGB is used by many professional printers and can be used by many home ink jet printers.

- sRGB is a space used by many types of computer hardware, including any monitor on your desk.

But there's another difference. Both spaces use the same amount of digital storage to indicate colors, so each can specify the same number of colors. But they treat those colors differently.

Adobe RGB covers a broader range of colors—a bigger palette, if you will—than sRGB. So you can get shades in the one that can't be represented in the other.

But everything has its price. By taking the same number of colors spread out more, Adobe RGB has more space between its colors, and transitions from one shade to the next may seem choppier than with sRGB.

The best answer, as I mentioned earlier, is to take pictures in RAW format. That way you can decide on which color space you want before you generate a JPEG or TIFF without a problem.

If you're capturing images as JPEGs, you have some problems. If you go from Adobe RGB to sRGB, the colors may seem washed out in the image. Going the other way can make some colors more saturated and garish than you wanted. I told you RAW was the way to go.

Thumbnail Tip

The biggest problems in going between Adobe RGB and sRGB happen in software on the computer. Your camera uses at least 16-bit color (and possibly 32-bit), which means each pixel can take at least 65,536 values instead of the 256 offered by 8-bits. That's enough information to make the problem of the space between Adobe RGB colors pretty much go away. But your computer image editor probably works in either 8-bit or 16-bit. Make sure you choose 16-bit so you can use Adobe RGB without paying the scaling price.

If you're bound and determined to capture your photos in JPEG format, give some thought before you click that shutter:

◆ If your images are primarily going to be seen on monitors (put on a website, as an example), use sRGB.

◆ If you're going to print the photos on a home ink jet printer, check that printer's documentation to see how to get it to handle Adobe RGB.

◆ If you're using a service to print your photos, ask them what you should use. Services mostly catering to consumers could well be using sRGB; professional services are likely to use Adobe RGB.

◆ If you are going to edit the image, capture it in Adobe RGB, edit it in 16 bits, and then use the resulting file or convert it to sRGB if it's to be seen on a monitor.

There are a few more color concerns you're going to have, such as white balance.

Juggling White Balance

If you're thinking that light is light, you're not quite right. What we call white light is really a combination of different colors. And different sources and conditions result in white light tinged with color. That tint is called the *color temperature*, as Figure 9.2 shows. As the temperature climbs, the tone gets more bluish; lower temperature means more red in the light.

Figure 9.2

A scale showing the color temperatures of common lighting conditions.

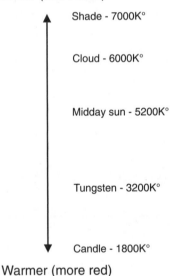

Cooler (more blue)

Shade - 7000K°

Cloud - 6000K°

Midday sun - 5200K°

Tungsten - 3200K°

Candle - 1800K°

Warmer (more red)

Photo Pro Jargon

Color temperature is the color cast of visible light, expressed in degrees of Kelvin. **White balance** lets you adjust how the camera compensates for the temperature of the light so that whites are really white. (Good grief, we've walked into a laundry detergent commercial.)

All EOS cameras let you set the *white balance* of the camera to compensate for the temperature of the lighting so colors come out the way you'd expect. You have four different ways of doing this and one way of covering your white balancing backside:

◆ **Auto white balance**. The camera makes a pretty good guess as to the proper setting, though it can be off from what you want.

◆ **Choosing a white balance setting**. You pick one of the lighting conditions, such as cloudy, shade, sunlight, fluorescent, or tungsten.

◆ **Selecting the color temperature**. You specify the temperature, in Kelvin, of the light. That means you have to know the temperature or make a good guess (or keep a copy of Figure 9.2 around).

◆ **Custom white balance**. You fill the screen with something that is supposed to be white or grey, take a picture, and the camera adjusts the white balance accordingly. It can be handy to carry a white or 18 percent gray (think Chapter 7) reference card for an accurate reading.

◆ **White-balance bracketing**. As with exposure bracketing, you take three shots. The first comes out with the set white balance, the second is bluer, and the third is redder.

TIFF Luck

Auto white balance is often fine, but it can be fooled if one color or a few related hues dominate the image.

How you set each of these can vary by camera model (as if you didn't know that already), so check your manual. But that won't tell you *why* you might want to go beyond the automatic setting.

As with the other types of file controls, it's all about getting an image that you want. Sure, you could set the camera for the "right" conditions or trust in the power of automatic control. You could also take some artistic license.

For example, say that you were taking a picture of a sunset and that you like the warmth of the pinks and oranges and reds. If you correct for white balance, a lot of that warmth will disappear, because the camera tries to "correct" what it sees. To keep the original sense that you liked, you might need to set the white balance a bit off deliberately.

Thumbnail Tip

If you want warmer tones than you're getting when you check the LCD screen, set the white light temperature a little higher. The camera thinks then that the image could be too blue and compensates accordingly.

If you want cooler tones, then set the temperature a little lower. The camera then compensates for what it thinks will be an overly warm image by cooling it down.

You'd Better Change Your Tone

There's another way of controlling how colors appear in your image: change the tone. (Yup, the manual tells you where in the menu you can find this.) This setting is primarily for altering skin tones to please your aesthetic sense—otherwise known as you'll know when you like it. Think of it as twiddling the color tone control on your television set and watching the faces go from blood vessel bursting red to sickly green. Except here the color shifts between reddish (the minus values) and yellowish (the plus values).

Saturation Shooting

Finally, we get to saturation. This means that you can adjust how vivid the colors will appear. I find that given different subjects and my own whims, different amounts of saturation make sense. A lot of times I enjoy having a saturated landscape—really getting those greens and blues to pop up. But if I were shooting a portrait, that would look … well, weird.

Contrasting Choices

Aside from everything else, you also have control over two things that are actually related—contrast and sharpness. The first one is pretty straightforward. Contrast is the difference between the brightest and darkest part of an image. Have too much, and the result can look harsh and glaring; too little, and the image can look washed out and flat. Figure 9.3 shows three versions of the same image, all with different amounts of contrast.

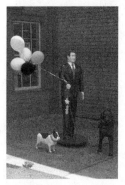 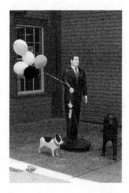

Figure 9.3

The left version has contrast pushed to the lowest setting. The middle is at "normal" contrast, and the right one is at the highest contrast setting.

Try this as an experiment: shoot the same scene while changing the contrast setting (see your camera manual for how to do this). Check the results and see which is more pleasing to your eye.

But what does contrast have to do with sharpness? More than you might think. A sharp photo is more than just keeping steady, focusing, and choosing the right depth of field. The processing software in the camera can actually make things look a little sharper or softer by increasing the contrast at points where different colors or tones come together. What the software does is change that local contrast without necessarily changing the overall contrast of the image. Figure 9.4 shows an example of what changing sharpening can do.

Like with contrast, there's a trade-off when you increase sharpening. Do too much and you can find little halos around everything.

Figure 9.4

The left version has sharpness pushed to the highest setting. The middle is at "normal" sharpness, and the right one is at the lowest sharpness setting.

News Flash

You'll probably find that certain combinations of image and file settings satisfy you in given circumstances. The way to get them is by using the Picture Style feature (see the camera manual for instructions on how to use it). Your camera already has some defined types, such as portrait and landscape. Not only can you adjust the sharpness, contrast, saturation, and tone of each type, but you can define your own types. Who says you can't always get what you want? The other way to go is to shoot RAW files with everything set to "normal" and then apply all these controls on your computer where you can see what they do more easily and not have to remember which setting you've got the camera on now.

Your Personal Camera Store

You gotta put those images somewhere, and that's on a CF card. Mention storage at a gathering of photographers, and you're bound to get a debate. Some shooters won't use anything larger than a 500 MB card because should something go wrong with the card, you might not have all your images there, so you could salvage at least some of your pictures.

I understand that concern. But I tend toward another school of thought: use larger cards to cut down the time swapping them and potentially losing that great shot. I typically bring several 1GB cards with me when I shoot, and I've never had one give out on me yet—and they've been in service anywhere between two and four years.

When you go shopping at the store for that storage, look at the professional or fast cards. These versions can pull data in faster than their ordinary brethren, which means that you free the buffer faster. Therefore, in theory, you have more time to shoot. And some of them (Lexar's for example) come with recovery tools, so if the worst happens, there's still a chance that they won't be relegated to cold storage.

The Least You Need to Know

◆ Record images in RAW format to get the best quality.

◆ Use Adobe RGB unless you won't be printing your photos.

◆ Color-related settings can help you create the image mood you want.

◆ Set picture styles for your most common image settings.

Chapter 10

Body Guards

In This Chapter

- ◆ Protect your camera body and attachments
- ◆ Keep your lenses from harm
- ◆ Safeguard CF cards

It's a hard knock life—just ask Charles Strouse and Martin Charnin, who wrote the music for the Broadway show *Annie*. For most of us, that means the occasional bruise or nick. However, while the EOS equipment is well-made, it doesn't have the nifty self-healing capabilities of human skin.

It just takes some foresight—learning how to treat your equipment and taking care before one of those nasty hard knocks happens. If you protect it, it lasts a lot longer. There's also a bit of extra equipment—a bag here, a filter there. But the investment is worth it, and a whole lot cheaper than buying new gear.

Bag It

Think of a stereotypical amateur photographer and you'll see some-one with a camera slung around his or her neck for hours on end. The professional also has the camera out—when shooting. Otherwise the equipment resides in a bag. There are some good reasons why people who make their living with photography use camera bags:

◆ It's a convenient way to keep all your gear together in one easy-to-find place.

◆ You can bring extra lenses and other paraphernalia you might need.

◆ Bags are cushioned in the interior to safely cradle what they carry.

Thumbnail Tip

Your bag can make a great impromptu tripod. Put the bag down on the ground, on a table, in your lap, or anywhere else that's steady. Put the camera onto the bag, take aim, and shoot. I did this just the other day when I had to photograph a theatrical performance and had forgotten my monopod. (See Chapter 4 for more ways of keeping the camera steady.)

There are a number of good camera bag manufacturers and each can easily have dozens of models. Before you start playing eenie, meenie, minie, moe, let's simplify things. There are four general types of bags I've seen on the market:

◆ Cradles for a camera and one lens

◆ Shoulder bags

◆ Backpacks

◆ Wheeled containers

Cradles

The simplest is the one camera cradle, such as in Figure 10.1. It may strap to your back, hang over a shoulder, or even sit on your hip on a

belt. Although I've not used them much in the past, I find them attractive when I want to carry a minimum of weight yet still need a safe place to keep the camera.

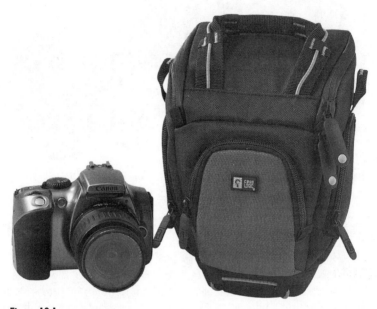

Figure 10.1

Just enough room to keep one camera safe.

Shoulder Bags

Shoulder bags are a decades-old favorite of the photojournalist that has to schlep any amount of SLR equipment around. The bags come in different sizes, from small ones that hold a camera body and two lenses to monsters that can hold a couple of bodies and five or six lenses. I must confess that I have a few shoulder bags (though not as many as the handbags that grace my wife's closet).

With a smaller one I can bring a lightweight kit of one body and two zoom lenses. But when I'm working or just want to do some serious shooting in digital, I use a Lowepro Stealth bag (Figure 10.2 has a picture of one). It has plenty of room for my preference of three to four fixed-focus lenses (see Chapter 3 for the difference between fixed-focus and zoom lenses) and has a laptop insert at the back. The zip-open top gives me quick access and there's even a built-in rain cover.

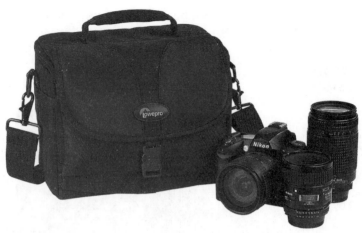

Figure 10.2

My personal preference for a shoulder bag.

> **Thumbnail Tip** _____
>
> Bag manufacturers have shoulder bags and backpacks with room for a laptop because so many professional digital photographers bring computers with them to dump images onto the hard drive and edit their photos when they aren't shooting. If you find yourself traveling in an airplane with your camera and your laptop, it's also a great way to get all your really expensive stuff into one bag and bring it into the cabin with you, rather than checking it.

Shoulder bags do present two problems. If you load up a larger one, that becomes a heck of a lot of weight hanging from one side of you. Combine that with a lot of walking, and the result could be a sore shoulder and neck. I keep switching the bag from one side to the other, and sometimes use the hand strap to hold it, just to keep it from sitting in one spot.

They can also be large and clumsy. If you're moving in crowds or through confined spaces, you have to develop an awareness of where it is so you can keep it away from where it shouldn't be.

Photo Backpacks

An alternative that I like on days that I know I could be carrying equipment for hours is a photo backpack, such as the one in Figure 10.3. You

sacrifice some convenience; changing lenses, grabbing a flash, or snagging a new CF card means taking the pack off, getting what you need, then putting it back on again. What you gain is comfort. The weight sits on your shoulders and is distributed evenly across your body. It's the same principle used by hikers, though you probably won't be carrying 60 pounds of stuff along the Continental Divide.

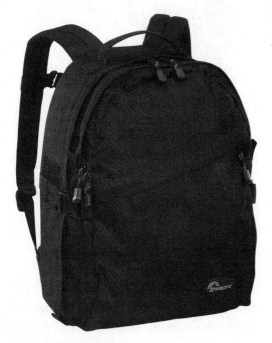

Figure 10.3

A comfortable and compact way of carrying your gear.

Wheeled Container

Last but certainly not least is the wheeled container, as in Figure 10.4. I have a couple—not for digital equipment, but for large format work (you know, the type with the bellows on the front and the cloth over the photographer's head). If you need one of these, you've gone off the deep end and are probably single-handedly ensuring Canon's financial success.

There is a hybrid that can be useful: the photo backpack with wheels. You can keep it on your back, or pull out a handle and wheel the little devil around behind you. It's a bit clunky, but if you're facing long stretches in airports on your way to some exotic locale (or in a layover at Newark or Houston), you can let the pavement carry the weight.

Figure 10.4

The assault vehicle of the camera bag world.

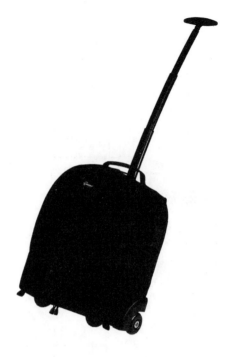

What Bag Fits You?

Ask a group of photographers what bag system to use and you're likely to get a range of answers all grounded in complete surety. For example, I've been using Lowepro equipment for years. In a conversation with Ian Macdonald-Smith, a wildlife photographer and "Olympic Visionary" (not sports or Greek mythology—he's sponsored by another camera company because he's a Photo Big Thing), for an article I was writing, he said he's a real fan of Tamrac bags. There are other perfectly decent manufacturers as well, and it doesn't matter at all which one you choose so long as that system suits you. You want to get to the point where you just reach for what you need without looking.

My suggestion is head to a good pro camera shop that stocks a number of lines, take a good hour, and open them up, explore how they store lenses and bodies, put them on. If none grabs you, see what other manufacturers' lines are at other stores. Eventually you'll find one that just feels right. This may seem obsessive—heck, this may *be* obsessive—but this ultimately will be time well spent.

Safety Glasses

Even though your bag is holding all the equipment, lenses need extra care and attention. As I said in Chapter 3, when it comes to getting a good picture, they are the single most critical item. They also happen to be the most easily damaged piece of equipment: you can scratch that really expensive glass in the beat of a butterfly's wing. Even if you don't damage it, fingerprints or dust can start messing up your pictures.

So we're going to look at a four-part regimen to keep those lenses (and photos) looking good:

- Cleaning
- Safety filter
- Protective caps
- Wraps and cases

Don't worry—this will take you little to no time and a small enough investment that raiding the jar of left-over change will more than suffice.

Spick and Span

Cleaning is the most basic, because you want the lens clear and ready to work when you stow it away. You'll need the following supplies:

- Blower
- Sable artist brush
- *Lens tissue*

◆ *Lens cleaning solution*

◆ *Micro fiber cloth*

Photo Pro Jargon

Lens tissue is a thin soft paper designed to clean lenses. **Lens cleaning solution** is a chemical fluid for cleaning residue. A **micro fiber cloth** has tiny fibers that can absorb oil and dirt without scratching the glass.

And here are the cleaning steps:

1. Brush/blow away dust.
2. Inspect the lens.
3. Clean remaining spots.

You want to remove the obvious bits that are sitting on the surface of the glass at both ends of the lens. Start with the outer end that points towards your subject. The safest way of getting rid of loose dirt and dust is to use a lens brush or to crumple a piece of lens tissue and gently flick the dust away. You can find plenty of lens tissues in the marketplace. (A particularly good one to look for is the PEC-PAD brand by Photographic Solutions.)

If the debris hangs on for dear life, then you can try a bulb blower that photo supply shops carry to see if some gentle persuasion helps. One particularly good brand is called a Rocket. It looks like a space ship and offers strong blasts.

There are cans of compressed air that photographers and graphic artists use, but I'd suggest avoiding them. The jet of air can be so powerful that it drives grit and dirt into the edges of the lens where they lodge. It's the optical equivalent of sweeping under the rug, and will only come back to haunt you. But if the dust is clinging, it may be necessary.

Getting rid of dust and dirt from the back end of the lens can be a bit trickier as the rear element is often recessed. In that case, a combination of blower and brush should do the trick.

After you have brushed or blown away loose dirt, look at the lens surfaces under good lighting. There may be oil, salts, or other substances left as patches of film. They won't brush or blow off, so you need to do something more. If all that's there is a finger print, then gently wiping

with a micro fiber cloth should do the trick, though make sure you regularly wash it and keep it in a plastic bag to avoid introducing dust or lint. If you're looking at something more stubborn, use a lens cleaning solution and tissue or pad. (Photographic Solutions makes one called ECLIPSE.)

Thumbnail Tip

If you have to use a blower or compressed air, aim at about a 45° angle. Approach close to perpendicular and you're blowing the dirt straight in, not encouraging it to move off. Too shallow an angle and you increase the chance of driving specks into the edges of the lens. You can also try pointing the lens surface face down and blowing, letting gravity help pull the material away.

Don't use a household cleaner, even if supposedly for glass; it can have ingredients that could cause problems for the high tech optical coatings. I'd go with a brand name before saving a dollar or two on an unknown knock-off; my lenses are worth far more than that.

Don't put the fluid directly on the lens, because what it dissolves could end up washing inside. Put a few drops of cleaner onto a lens tissue or pad and gently work at the spots.

TIFF Luck

Those who say that you can never be too rich, too famous, too good looking, or too clean are probably too obsessed. They also don't know camera lenses. Every time you clean the lens, you run the risk that a bit of dust or dirt, pushed by your dutiful hand, will plow a neat channel in the glass. Also, keep taking cleaner and lens tissue to the glass surfaces, and you can create permanent cleaning marks where you literally have wiped away part of the high tech glass coatings that help ensure visual quality. Yes, it's nice to get that spec of dust off the lens, but, please, let's have some moderation here.

Cleaning is important, but the best way to keep lenses at their best is to keep dust and dirt from getting to them in the first place. That's what the next two sections cover.

Filter Out Danger

One protective option you have that keeps out much of the dirt of life and that also wards off injury is a filter. Screw on one of these to the front of your lens, and while its open and exposed when mounted to your camera, if a ding or scratch heads for the glass surface, it will smack into the filter instead. Replacing that shield is a lot cheaper than buying a new lens.

The trick is finding a filter that won't significantly alter the image you wanted to get in the first place. ("Daddy, why is everyone's face green?" "Go ask your mother.") The usual choice is an ultraviolet or sky light filter (see Chapter 3 for more on filters). Neither will affect your exposure times nor change the colors that you see. If you are using another filter for a shot—say a polarized—then you can remove the protective filter for the duration of the shot.

Cap Fun

Another protective barrier is the *cap*. Using both a *front* and a *rear cap*, you sandwich the lens between layers of hard plastic. When you've got a lens mounted on the camera, you keep the front cap on when you're not shooting to keep the otherwise exposed element safe.

Photo Pro Jargon

Caps are plastic contrivances that cover the ends of a lens, keeping it protected. The **front cap** covers the outward facing part of the lens, while the **rear cap** is for the part that connects to the camera body.

Wrapping Up the Case

When you're not using a lens, keeping it in a camera bag is usually the smart way to protect it. However, if you're going on safari, taking a biplane to a remote volcanic island, climbing Mt. Everest, or otherwise endangering your camera equipment in your mad quest for adventure and excitement, some additional protection can make sense.

Camera wraps are thick pieces of cloth that enfold your camera; hook and loop fasteners (Velcro to the brand-name conscious) keep the corners in place and the lens snug. Although typically used with special equipment that uses large sheets of film, they're good to know about. If you're going to be near the beach, a lake, or a river, you can get waterproof camera equipment cases, though they only provide protection so long as they are sealed, and they can be pricey. There are even waterproof bags meant to hold a camera while you're using it, if you are feeling particularly nervous.

There are also cases for individual lenses. Few need them, but when you get into the really long telephotos, you might find that the lenses are simply too big to fit into your camera bag. Typically one of these larger lenses will come with its own case (and with the prices they run, it should also come with someone to carry it for you).

Don't Let the Chips Get Down

Sure, sure, worry about the camera, fret about the lenses, but what about the poor CF cards? Remember them? The ones that slave away in the dark, holding all those images, unappreciated? Because they are probably the most expensive component by weight of anything in your camera bag, you want them to last a long time.

They do come in those little plastic hinged things, but my suggestion is to forget those and go for a padded memory card case that can hold a few of them. I prefer a zipper rather than those plastic latches, though if you're going to be in inclement weather, there are actually waterproof cases that travel where zippers dare not go.

The Least You Need to Know

- A good case protects your gear and is convenient to use.
- Clean your lenses—but not too often.
- Filters and lens caps are great shields against disaster.
- Don't forget to put your memory cards into their own case.

Part 3

Advancing Your Technique

Once you have the basics down, you might find yourself getting more ambitious. If so, Chapters 9 to 14 are where you want to be—among techniques that can improve the types of shots you've been taking.

You'll start by understanding more about the actual image files and what you can do to change their performance. Moving into ambient lighting and flash photography, you then discover how to best set up for different types of subjects and conditions, then adjust and control the image in your digital darkroom.

Chapter 11

You Light Up Your Life

In This Chapter

◆ Lighting placement

◆ Using ambient light

◆ Tricks for daylight shooting

◆ Using flash

By this point you've learned enough about your EOS camera and exposure to know that the picture your eye sees isn't necessarily what comes out of the camera and onto paper or a monitor. One of the big reasons might be light. As Chapter 7 said (and said and said), you need enough light to get a well-exposed picture. But that alone isn't enough. If you have too little light in places or too much in others, you might wish that there were none at all.

Not to worry, it's time to learn to fix this. Some methods won't require anything more than learning something a bit more about how to use the light you find. That can include adding some low-tech equipment to help direct illumination where you want it.

Other times, you'll need something more: artificial sources of light that you can pack with your camera equipment—and at least one of which is built *into* the camera body. You'll be able to

help improve pictures when you think you already have enough light and even magically stop time. (Even so, avoid tempting fate and stay out of the way of that oncoming train.)

Which Way Did It Come?

There's a goodly amount to know about lighting, but what can get you coming and going most is where the light arrives from. In other words, is the source of your light from one of the following?

◆ Above

◆ Below

◆ A side

◆ The front

◆ The back

◆ Or any combination of the above

The direction is going to affect the image mood, the attractiveness of the composition, and even whether all of your image is visible. What you face are shadows from objects in the scene. For example, if you're taking someone's portrait and you have the light coming from a ceiling fixture, chances are that without some care, the final image will have a shadow cast by the nose over part of the mouth. Or take a picture of a pet standing to one side of a lamp in an otherwise dark room, and you may find the poor animal looks as if one half of its face had faded away. Or you can have bigger shadows, as you can see in Figure 11.1.

No person or poor little pet here—this is the exterior of the mansion at the Marsh-Billings-Rockefeller National Historic Park in Vermont. But the principle of shadows raising visual havoc are the same. Remember back in Chapter 7 discussing latitude? This image is a case of latitude lassitude. You can see the parts of the scene in shadow, but the camera can't. In the case of Figure 11.1, if the exposure is bright enough to get details in the shadows of the bushes, the highlights of the shutters turn into what is technically known as a white blob. Reduce the exposure enough to show that the shutters are made of slats and the underbrush is undetectable.

Figure 11.1

Unbalanced light leads to unbalanced seeing.

There are ways of fixing such problems, including some pretty cool things you can do on a computer, which we'll get to in Chapter 14. But the basic principle is always the same: balance the amount of light in different parts of the photo. One of the best ways to do that is to use combinations of lighting angles to control the shadows in your pictures. Aha! No wonder we've been discussing the directions light comes from. (I had a sneaking suspicion all along.)

Lighting is like a box of ... no, wait, that was something else. Uh, lighting is like a seesaw. No, I used that in Chapter 5 (though it still applies). Okay, I've got it: lighting is like a balance scale. If you find it tipped all the way to one side, add something to the other. Photographers often talk about main or *key* lights and *fill* lights. The key light gets things bright enough to take the picture in the first place—it really sets the exposure. The fill light, or lights, are less intense than the key light. They help fill in shadows, hence the name.

Photo Pro Jargon

Fill lighting is additional light intended to fill in the shadows made by the **key** light providing the bulk of the illumination. (If it's light, how can it have bulk? Ah, why ask these questions?)

No need to make it complicated. Think of lighting as using a flashlight when you're looking for your lost keys under the sofa. You need to add more than what spills over from the rest of the living room if you're going to find them. Figure 11.2 shows an every day example of combining key and fill lighting.

Figure 11.2

Double side lighting for one look.

These two boys were in front of a computer monitor in a room without any lights on. On the opposite wall, an open door let in light from a lamp in an adjacent room. The light from the door provided the key illumination from one side while the monitor provided fill lighting from the other.

Of course, you can't always count on having a computer monitor handy when you need one. That's why we're going to talk about the different types of light you might find yourself using.

As You Light It

The quality of light is not paned; it droppeth like the gentle rain from heaven—or from the nearest artificial source onto the subject before you. Almost everywhere you go in the world there's light. In fact, sometimes, you just can't seem to get away from it—sunlight outside, bulbs brightening otherwise dark rooms, and the glow of cities and towns at night drowning out the stars.

What's bad for astronomers and the photophobic is good for photographers, since you need light to take pictures. And having light handy pretty much anywhere means you can conveniently take advantage of this *ambient lighting*. For most of what you will be doing, the types of lighting in the table that follows will be what you'll deal with.

Photo Pro Jargon

Ambient lighting means using whatever already illuminates a scene.

Light Sources

Type of Light	Where you find it
Sun	Frequently present outside, particularly during daytime hours.
Tungsten	Indoor incandescent lamps and fixtures.
Fluorescent	Commercial buildings and even in homes, particularly as manufacturers develop fluorescent replacements for traditional tungsten bulbs.

Because you can set the white balance on your Canon camera (see Chapter 9 for how to do this), you can use any of these lights to take a picture. You'll find these types of lighting pretty much anywhere you happen to be, unless you're deep in the bowels of a cave, in which case you'd best bring your own. It's all good, it's all ambient, and it's all lighting types that the EOS camera white balance system understands.

News Flash

Check your camera manual and you'll see that there are white balance settings for tungsten, for sunlight and shade, and for fluorescent. But there are two types of lighting I didn't mention in the table: halogen and mercury. They're the weird colored lights you might find outdoors in such chic locations as parking lots or warehouses. Both have odd mixes of parts of the spectrum of visible light and neither falls neatly onto the Kelvin scale. If you find yourself around them, the best approach is to use auto white balance and then adjust the color balance as Chapter 14 explains.

I'm a big fan of ambient lighting, also known as making do with whatever is on hand. You can get terrific results just by paying attention to how light around you interacts.

Look back at Figure 11.2. Because I used the lighting that happened to be there, it was ambient.

Sun-Day

My favorite ambient light source is a big one—the sun. However, it is one that can be fickle: different at various times of the day and under changing weather conditions, though when the sky is clear and you hit the *golden hour*, the results can be magical. Here's a table with a summary of some of the characteristics and conditions to look for when shooting outdoors.

Photo Pro Jargon

The **golden hours** are the hour after sunrise and before sunset when the sun offers a warm and flattering light.

Sunny Disposition

Conditions	Results
Golden hour (hour after sunrise and hour before sunset)	The best natural light you can find. The light is warm, gentle, and flattering, with very long shadows. Meter carefully if shooting toward the

Conditions	Results
	sun, because otherwise the meter might misread the scene to some extent and could underexpose your subject. Prepare ahead of time and watch the light for when it's right. If you shoot in the morning, you can keep taking shots after the hour. At the end of the day, you'll run out of sunlight.
Midday and mid-afternoon	Stronger than the golden hour. Shadows are shorter and may be more noticeable. The sun's position can make glare a problem, so shoot with a sunshade. In summer, morning will probably be more comfortable, whereas afternoon will be better for winter. Unless you're in Florida, Arizona, or other natural ovens.
Noon	Harshest and least flattering light of the day. Shadows cast down and can be distracting in a final image. I find noon to be a delightful time for a break and some lunch.
Cloudy or Overcast	Although the sky can be dull for landscapes, the light is even and diffuse, minimizing shadows and glare.

TIFF Luck

The golden hour is great, but might be a disappointment if you switch to automatic white balance. While AWB is often helpful, it will try to compensate for the very warmth of light that either has you up early or postponing the cocktail hour.

Although you may associate professional photography with all sorts of gimmickry, shooting in the proper choice of outdoor conditions can let you do amazing things.

Mix and Match

There will be times that you find ambient lighting coming from a number of different sources, all of different color temperatures. For example, you might want to take a picture in the middle of a room with sunlight coming in from a window and a strong tungsten lamp on the opposite side, forming a Kelvin color sandwich.

Getting a good white balance under such conditions can be a challenge. You have a few choices:

◆ You can turn or block off the light sources causing the problem. In the case of our room, it would be to switch off the lamp or even drop the window shades. You lose some light and may then need some fill lighting to replace what you dropped, but it can eliminate the white balance problem.

◆ Put some white object as a reference near the part of the image most important to you and do a custom white balance on it. Although some parts of the image may have an odd color cast as a result, at least you're keeping the important part clear.

◆ Make use of the different colors. I can remember once having to take a picture of a product I was reviewing for a magazine. So I set it up on my kitchen table in front of a makeshift background. Window light provided the key and I turned on the overhead tungsten to add a warm glow to the top. You could do something similar with any other subject.

Remember, you're working with a digital camera, so you can check the results on the LCD screen as you experiment. Try different approaches and see what works best for you.

It's a Hard Knock Light

When dealing with any source, you also have to consider the quality of the light—whether it's *hard* or *diffuse*. The difference is like that between a clear glass light bulb and a frosted one. Use the first and the shadows are all sharp-edged, the light harsh. Frosted, and the light makes everything look ... nicer. Light is harshest when it comes from

one source and goes directly toward your subject. When it's diffuse, it bounces around some, approaching the subject from a variety of directions.

When you use more than one source of light, it mixes about and, as a result, softens the image. Sometimes soften-

Photo Pro Jargon

Light is **hard** when it is strongly directional and casts sharp-edged shadows. Light is **diffuse** when it is scattered from the source and creates blurry-edged shadows.

ing the light is what you want, particularly if you want to light Ingrid Bergman through her close-ups in *Casablanca*. There are ways of controlling light so that, to a reasonable degree, it does what you want it to do.

Train That Light

You won't need a whip and a chair for keeping the light in line. Yes, I know that's disappointing, but we're trying a nonviolent approach. And in this case, nonviolent means we get to use basic fundamentals of how light reacts to coax it to see things our way.

We were just talking about diffuse light. Getting that Ingrid Bergman moment is much easier than you might think. Say you're inside. One step would be—replace those glaring bulbs in the lamps with some frosted ones. Or hold up a piece of translucent material between the light and the subject. You'll lose some light and need to use either a slower shutter speed or a larger aperture, but it can be an aesthetically smart trade-off.

Thumbnail Tip

Not even the sun is too big to handle, even at noon. Tie fabric to an open frame, or a couple of people in your handy press gang, and hold it between the sun and your subject. All around may be harsh, but under the protection of your diffuser, the sun is a gentler thing. If you're handy, you can make a rectangle of PVC piping large enough to hold the fabric. Less handy? You can always order this type of frame from one of the pro photo supply shops—B&H Photo, Adorama, or Calumet are three good sources. (See Appendix B for contact information.)

Another great type of tool is the reflector. Some of the things you can do are fill in shadows, balance the lighting in a scene, or even add glittering highlights to someone's eyes. Yes, mirrors work if you have some large enough and you don't mind the hard light that reflects off. But there are plenty of other things to use, including:

◆ Aluminum foil (in pristine sheets or crumpled up)

◆ Foam core boards (an artist's medium that is stiff and light with a bright surface).

◆ The brightly painted side of a building

◆ Someone nearby in a white shirt

◆ A cosmetic mirror

Anything goes here, including using colored reflectors to add a sense of additional atmosphere. You can get professional reflectors—intriguing flexible rings to which you affix your choice of reflecting fabric—maybe white, silver, or gold, for that warm look. When you're done, a twist of the wrists and it collapses down into a much smaller package that fits into a zippered case. I use them all the time. Need to have *less* light in part of the scene for more drama? Cover that reflector with black cloth and let it absorb some of those extra photons. Just get inventive and see what works and say, "Not only am I a photographer, but I'm an inventor, too."

Flash in Your Plan

But sometimes, no matter what you do, you need more light. It might be that you're taking pictures in a dark area. (Whatever happened to that "glow from the towns and cities"? Did they all have a blackout?) Or you might be photographing someone on the beach and need to get his or her face properly exposed without over-exposing and washing out the surf and sand. You definitely need a *flash*.

There is a small one built into your EOS DSLR. Press the right button (check your manual), or let one of the basic zone operating modes get it going for you. But that's pretty limiting. There's only so much light it can generate, and a flash with too little light is like … nothing. The

more light a flash can generate, the bigger and farther away an area you can illuminate.

So I'd suggest getting a separate flash, and not just any model. Get one designed to work with your EOS camera. If you do, you'll find that the camera can handle much of the light metering and

Photo Pro Jargon

A **flash** is actually a type of **strobe**—a device that pumps out brief bursts—we're talking thousandths of a second here—of light about equivalent in color temperature (see Chapter 9) to a cloudy day.

calculations for how to set the flash unit to get a picture without having to invest too much thought. Though be sure there are options for manual control. For example, if you're taking someone's photo outside at midday (didn't I tell you that lunch was a better idea?) and you want to eliminate a shadow under the nose, you could use a reflector, or you could set a flash to pump out just enough light to act as a fill.

In those cases, you need to understand something about flashes. They work strictly based on the f-stop you have set and how far you are from the subject. Their not influenced at all by the shutter speed. If you think about it, this makes sense. A flash burst lasts for maybe $\frac{1}{20,000}$th of a second. It's woken up, worked, and headed home by the time the shutter gets to the office.

Thumbnail Tip

Flash can also help you stop action in two ways. One is that if you're using fill flash, then the extra light lets you use a faster shutter speed. But when the strobe is the key, then you illuminate the subject for such a short period of time that you can freeze almost anything. Sometimes the effect can be interesting, as when the subject is frozen but you also have a ghostlike image taken between when the shutter opened and the flash went off. Or you can use a technique called second-curtain flash. You set your camera to use the feature (check the manual for whether yours does this and, if so, how). Put the camera on a tripod, use an exposure with a slow shutter speed, let the subject start its motion, and press the shutter button. The flash goes off at the very end of the exposure, and you get the final image with a trail behind it.

To use a flash as a fill light can be tricky if you have to work things out manually. You're balancing the distance to the subject against the f-stop you need for your exposure, then setting the flash so it thinks that the f-stop is actually smaller (bigger aperture) than you're actually using. That way it puts out less light and doesn't overpower the exposure.

This is why you want a flash compatible with your camera. The Canon's metering can do a pretty good job of working with the flash to set it so that it lights enough for the shadows but not so much that it makes the entire shot too bright. And if that doesn't work, look at the manual for how to change the f-stop setting of the flash and experiment. Hey, it's digital and you don't pay for processing.

Taking the Red Eye and Other Fancy Moves

You probably won't be doing overly fancy flash work, but even so, there are some tricks you should know about. One is using multiple flash units. There are different ways of setting off more than one. Depending on the manufacturer, it may be any of the following:

- ◆ An infrared pulse detector
- ◆ Wireless radio technology
- ◆ A built-in light-sensor

The remote flashes look for a signal from your main flash and go off when ordered. You don't need something like this too often, but if you have to get more light in on a shot and you're taking a picture of something large (like your next family reunion), you could need more light than the one unit can give.

Something of more practical use is dealing with red eye. You've probably seen photographs where the people have weird red eyes, like they were some out take from a television series like *Wilhelmina the Slime Mold Killer*. If you take pictures of people with a flash, you might even be looking at your own results.

It happens when the flash lines up over the lens—just what happens when you use the connector at the top of your camera. The flash goes off, the light travels a gazillion miles an hour into the person's eyes, bounces off their retinas (lots of red blood vessels there), and comes racing back into the lens, to be recorded as *Portrait of a Demon*.

You can fix that on a computer (see how in Chapter 14) if you want to spend the time.

Or you can fix it one of three ways when you take the picture. Your camera might have a red-eye reduction feature. It makes the flash unit set off a smaller flash to start—and to startle, for that matter. The subject's pupils retract, making it harder for red eye to occur. Then the main flash goes off.

You can use a separate flash unit and attach it to a separate flash extension cord. The cord connects to the flash unit and to the camera. Voila! You hold the flash to the side so you haven't lined up it, the lens, and the eyes. It can be awkward to hold, so try it at first with a tripod.

Failing those, you might want to modify the way your flash unit works. Don't take out the hammer and soldering iron; there are some easier ways.

Changed in a Flash

Flash can be pretty harsh light, but you don't need to put up with it. Often the easiest solution when using a separate flash is to point the light up toward the ceiling, a technique called *bouncing*. You can actually bounce a flash off a wall—or even the floor, if that takes your fancy, or off a big white sheet or card held to one side. Because the surface isn't a really good reflector (unless you're in a honeymoon suite in the Poconos or standing under the mirrored ball in a disco hall), the light becomes thoroughly diffuse and soft. You do have to take care, though. If the surface is really, really dark, you may get a really, really small amount of light. And a colored surface will tint the light.

Photo Pro Jargon

Bouncing is a technique of pointing a flash unit somewhere other than the subject—like a ceiling or wall—and using the reflected, more diffuse light.

If there's no appropriate surface at hand, then you can create one. A number of companies have kits of special reflectors that attach to flash units. They look like odd hoods, open to the flash unit and with an open part facing out. You set off the flash, and the light bounces off the inside of the reflector and out the open side. Some of the kits have

extra diffusers you can snap into place for even softer light, as well as gold and silver colored inserts to get a warmer or cooler light. (For a sample of what is available, see some of the pro photo store listings in Appendix B.)

The Least You Need to Know

◆ Balance the sources of your lighting to get the amount of shadows that you want.

◆ The golden hours are the best for outdoor shooting and midday is the worst.

◆ Diffuse your lighting sources for different results.

◆ Use flash as fill or key lighting.

Chapter 12

So Special

In This Chapter

- ◆ Portraits
- ◆ Landscapes and wildlife
- ◆ Sports and action
- ◆ Low-light and night

Shutter speeds, apertures, focal lengths—you're learning all about these to take pictures. Well, that was pretty darned obvious, wasn't it? However, it's not always obvious how to combine everything for a particular shot.

If you think about it, though, most of the pictures you'll take fall into one of only a few categories, such as landscapes, portraits, sports, close-ups, night shots, wildlife. Many of these are in the basic zone of your camera's operating modes, but then you're stuck with the exact settings the camera offers.

That's why in this chapter, we're going to look at some popular types of shots you might like to take, as well as look at some settings and techniques that will give your photos some punch. Don't expect hyper extended smiles and bland "nice" landscapes here.

Family and Friends

The most important subjects for you are going to be the people you want to remember, sometimes in circumstances they'd love to forget. Whether the subjects are adults, children, or pets, it's portraiture.

Lens

A solid approach is to use moderate telephoto, whether fixed focus or the appropriate setting on a zoom. In 35mm photography, an 85mm to 100mm focal length would be good. That lets you get a large enough image without having to sit in the subject's lap and without introducing potential distortion that you'd see if you took a wide-angle lens and got really close to someone.

But remember that lenses have a focal length multiplier effect, as Chapter 3 explains. With the consumer and prosumer EOS bodies, a given lens's focal length will act as though it's 1.6 times the actual number. Because we're looking for something to act as though it has a focal length of about 100mm, we divide 100 by 1.6 which is 62.5mm; divide 1.6 into 85mm and you get 53mm. Therefore, any focal length from about 50mm to 65mm should be fine.

That's for a formally posed shot. I happen to prefer candid photos, catching someone when they're being genuine and not smiling for Aunt Gertie. Even when I'm taking a portrait for money I typically want that feeling. So I'll use a fixed focus 200mm lens and get some distance back.

Settings

There are a couple of ways to go here. One is to get the focus on the face, so I'll use a small f-stop for a shallow depth of field. I'll go for f/2.8, or even lower if the lens I choose can do it, to get a blurred background. Because the aperture is so open, chances are that my shutter speed will be relatively high—unless I'm taking the shot in some dim location—making a handheld shot much easier to pull off if I need to.

Thumbnail Tip

If you're shooting with a low f-stop, make sure that the AF point you select is centered on one of the person's eyes, which are the single most important feature. Not only do they carry much of the emotion, but they have the fine details of the lashes. Depending on how much of the frame the face takes up, the depth of field could be only a matter of inches. Have the eyes even slightly out of focus, and it won't matter what else in the face comes out. Depending on the shot, you might have to use the focus lock technique from Chapter 6, and then move the camera to get the right framing.

You might also want to photograph someone in the context of their surroundings; sometimes environment can say as much about people as their looks, and, after all, portraiture is an impression of a person. *Environmental portraiture* is one specialized type, where you take the picture in someone's home or office or other frequent haunt. Any time the context is important, you need to capture it, so forget shallow depth of field. You need enough detail to see where the person is so you show the natural habitat. (Maybe I should have listed this under wildlife photography.)

Photo Pro Jargon

Environmental portraiture is where the surroundings a person is typically in are an important element of the image.

Portraiture is also where you'll want to play around with the color tone to emphasize the skin. This is totally a matter of personal taste. Some prefer completely faithful reproductions and others like a lightly warmed tone. You can set a tone preference on your camera, but instead I'd, as usual, suggest shooting RAW and changing this particular setting on the computer, where the bigger monitor gives you a fighting chance to see the differences.

Style

You've typically got two choices here: formal and candid. In the former you arrange one or more people, trying to get a good composition.

Formal shots can be tricky in a number of ways:

◆ People freeze up and put on fake smiles automatically.

◆ Every detail counts, down to whether someone's collar is askew.

◆ When you have more than one person, you'll have to move them around like flowers in a planter until you get an arrangement that you like. At least you don't need to add greens.

Use a tripod in formal shots. From a completely practical consideration, you can fix the positions of the person or people and the camera, getting the framing you want, then walk over and make the minor adjustments in clothing, hand and arm positions, or whatever else makes you feel that you're creating a masterpiece. The tripod also helps create an air of authority that says, "I'm the photographer, obey me."

For the candid shot, keep your wits about you and auto focus on. You'll probably be hand-holding the camera (though don't discount the sneaky approach of using a tripod, appearing to be looking elsewhere, and then suddenly swinging around and catching someone).

Thumbnail Tip _____

One of the best ways to get a candid expression is to let someone think they're getting a formal portrait. Get the camera on your tripod, frame the shot, get your finger on the shutter button, and have the subject say cheese, or an equivalent for the lactose-intolerant. After people hear the click of the shutter, they relax and become more themselves. Keep looking through the viewfinder, and when you see that fleeting moment—they'll pay attention to you again in just a second—press the shutter a second time. Now you've got 'em.

Children are a special form of portrait challenge. Sure, you can dress them up, but can you get them to sit still? The secret is to take your posed shots if you must, then turn them lose and bring your camera. Kids are fascinating because they're so alive and involved with the world. Have something around to play with and stay close but don't hover. Take lots of shots so you'll end up with some keepers. By the way, "kid" is a relative term—literally in this case. Figure 12.1 shows how you can catch your teenager in a moment of unabashed frolic.

Figure 12.1

A little bit of play gets every-one to drop their guards.

Pets can also be tough subjects. They keep moving around like animals! Can you believe it? One approach is to treat them like children, in that you let them get interested in something and follow them around, looking for the photo op. If your pup has decided not to run for office, you can try a posed image with the human relations. Get everyone in place and completely set up the shot. Then put the pet with the designated handler and take it fast.

Over There and Here

Next to people and pets, I'd guess that landscapes are one of the all-time favorite photo subjects. Although they seem simple, think about all the pictures of woods or beaches that are boring. If you're going to do it, do it right. Sometimes that will mean a traditional landscape. Other times you might want to try a wildlife picture, showing what lives in them thar woods. And still on different occasions you should consider a macro shot, getting close to nature.

Lens

Typically you'll want to use a normal or even wide-angle lens to get the sweep of the scape. You won't need a particularly fast lens, as you want enough depth of field to get the horizon and, possible, something providing some scale in the foreground (see Chapter 5 for more on this).

Don't forget, though, that atypical approaches often provide the most interesting photographs. Don't shy off from bringing a long telephoto, and maybe a telephoto converter to get a close look at a detail on the horizon. You don't have to lose the trees for the forest. The same setup will let you take pictures of wildlife.

For getting close up to the world, you can use a telephoto from a distance, or you can purchase a macro lens or close focusing attachment to get you close to a subject. Great for bugs and buds, I'd avoid the bears.

Settings

Because you want extensive depth of field for landscapes, you'll be using bigger f-stops. Color saturation, whether you choose it on the camera or in the computer, will be an important aesthetic expression. (Oh, you artist, you.) Experiment with different saturation levels, particularly comparing normal with extra saturation; you might like colors that really *pop*.

> **Photo Pro Jargon**
>
> A photographer says that something, particularly color, **pops** when it is vibrant enough to stand out and grab the notice of the viewer.

Wildlife can be a lot like sports photography, where speed is everything. That might force you to lower f-stops, or maybe not; it all depends on the strength of the sun that day. I've caught birds in midflight, such as in Figure 12.2. I used a 200mm lens at $1/3{,}000$ sec. and f/6.7. The choice of aperture gave me a little focusing leeway if things were off, yet, in the bright daylight, still let me use a pretty fast shutter.

For a macro shot, you're probably going to blur the background to at least some extent because you are significantly filling the viewfinder with the subject. But you might still be able to focus *behind* the subject and get something more, using your knowledge that depth of field runs behind and in front of your focal point.

Figure 12.2

One bird taking off and the other landing.

Style

When shooting a landscape, use a tripod and pay close attention to the horizon. Does it look tilted, as if it had one too many at the bar? Get it level (assuming that you're not obviously turning a hill on its side). Consider that the landscape isn't going to look the same no matter where you plop down. Try the view from different heights to see what it does to the perspective. Also remember that if the entire landscape is the subject, the eye is going to wander, particularly if everything is arranged along that one horizontal line, the horizon. And check Chapter 3, because you'll at least want a haze filter if not a polarizer to get more contrast and to eliminate haze that can make your image look weak.

For wildlife, patience is a virtue. You might be able to catch something unexpectedly, like the odd aggressive squirrel. However, experienced wildlife photographers will stake out their subjects, studying up on their habits to know where they will go and how they'll act. You might have to quietly wait a good while, but the results will pay off. Patience and foresight also work well if you want macro shots of the flora and fauna. If bugs or small animals are your passion—and I probably don't want to know any more in that case—set up your shot near where you can find the subject and wait. Or try some bribery with a bit of food left where you want the subject to be in the picture.

News Flash _____

As I mentioned under lenses, if you really want to do macro photography the right way and get that official license to join butterflies close up, you'll need the close-focusing equipment. However, you're probably not going to notice much difference between that and a good telephoto set up just close enough that you can get a large image of the bug.

Play Ball

Lots of people are sports fanatics, so chances are that either you'll want to take shots of athletes, either amateur or professional, or you'll get asked by someone to apply your superior photographic skills. And even if you don't hang with the hardcore, how about touch football games? Kids running around at a birthday party? Splashing at the beach? A medieval fight as in Figure 12.3? It's action pure and simple, and you're going to catch it with a basic approach and a few fundamental techniques.

Figure 12.3

Don't worry, they're jousting around with each other.

Lens

No doubt here—you want fast and long. Because you're on the sidelines (and please don't tell me that you're carrying your camera in the middle of a soccer game), anything less than a decently powerful telephoto will leave your audience in the bleachers. Look at the pros and you'll see lenses that can cost as much as a cheap new car. Go for a telephoto, use a converter if you need one, and be thankful now for that 1.6 multiplying factor.

Settings

You generally want fast shutter speeds to capture action as it happens. Don't worry about depth of field. This is another area where letting the colors pop can be good. Go for continuous shooting, not single-shot, and one of the AI-assisted auto focus modes, so when bodies are moving they're sharp. Forget any inclination to use flash to help capture the action; you're so far from what's happening that you might as well mail in the extra light.

Style

This is easy: know the game, anticipate what players will do, and keep shooting, preferably in bursts of continuous shooting at critical moments, so one of the shots comes out. Oh, and use a tripod. With the long telephoto or zoom, you'll get hand shake at the wrong time.

Then you can get the approximately correct amount of tilt and keep the lock open for rotation so you can smoothly follow people on the field, or court, or whatever it is that the particular sport uses. You should also practice *panning*.

Photo Pro Jargon

Panning is when you move your camera to follow your subject so you capture it while blurring the background.

Night Moves

One of my favorite types of photography is in areas with low ambient light. That can mean street scenes, poorly lit rooms, jazz clubs, or

anywhere else that illumination takes a holiday. And to get a better sense of what the world is actually like, I rarely use a flash. Although the strobe burst can make a subject stand out, it does overpower the ambient light and you lose something important.

TIFF Luck

In some places, such as concert halls and theatres, you'll probably hear either "No flash photography allowed," or "No photography allowed." If the former, just think to yourself, "That's ok, I don't need one." In the latter case, just pack up the camera and enjoy the show.

Lens

Only one thing counts here—speed, because you might have to hand-hold the camera at pretty slow shutter speeds. I find myself often shooting at f/2.8 at most, and down to f/1.8 if I'm using my faster 50mm lens instead of the 200mm. This kind of lens speed costs bucks, particularly as you get into telephotos and zooms. You might be able to do with an f/3.5 or so, but it will make things a bit tougher.

Settings

The problem with shooting in dark places is that there's little light—hey, that's why they call it dark. If you're using flash, set the f-stop and get close enough to use the light. But if you want to get the picture of how things actually are in the dark, it probably means low f-stops and slow shutter speeds. Chances are that you'll have to set the ISO speed high, possibly 800. You can go higher—1600 and even 3200 with some of the cameras—if you can't get a fast enough shutter speed to capture what is going on. But then you get a lot of noise in the image that degrades the quality in the form of colored specks. It's a trade-off, though you can actually improve the image as you'll see in Chapter 14.

There is one type of night shot that can be a literal blast: fireworks. It has requirements all its own. Set the camera to the manual operating mode, because there's no way even the computer inside will help you with what's outside. You'll want f/5.6 for the aperture and a shutter

speed that will about match the time between that whistle as a given firework starts to go up and the last bursts it makes. More on this in the next section.

Style

You've heard the phrase slow and steady wins the race? The shutter is running slow, so you'd better be steady. In some concert extravaganza there might be enough lighting for a small town, so you might find that the shutter speeds are fast enough to let you hand-hold the camera. In most other situations, such as a jazz club or taking pictures of the goings on downtown, it's best to use a tripod. That may not be possible, so find alternatives (see Chapter 4 for some ideas). Figure 12.4 is a shot I took in Boston at one of the Playwrights' Platform annual summer festivals of new plays. My support was my camera bag, turned on end and set on my lap.

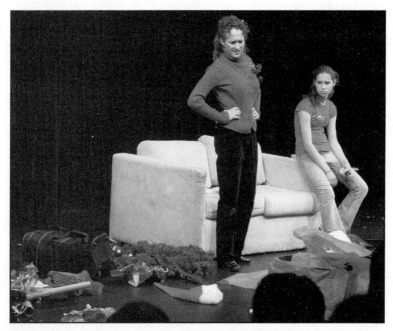

Figure 12.4

Actresses Penny and Alana Bensen carry the mother and daughter thing onstage.

If you're taking pictures of fireworks, watch one or two of them go up to see where to aim the camera (on a tripod). Count to see the time between that sound they make when they launch and the pretty lights. Set the shutter speed for the closest matching number. When you next hear one go off, press the shutter button and wait. Check afterward to see that you got the shot and adjust the camera position and shutter speed as necessary.

The Least You Need to Know

- Pick your lens and settings for the type of photography you're about to do.

- Use the right techniques for the subject.

- When taking a portrait, press the shutter button a second time when people let their guard down.

- Learn to take pictures in low light without a flash for a different type of image.

Chapter **13**

Building Your Digital Darkroom

In This Chapter

- ◆ Setting up a computer with muscle
- ◆ Handy hardware additions
- ◆ A handy software duo

One of the best things about digital photography—and the pictures coming out of your EOS DSLR count—is that you have an unlimited amount of control. I don't mean in the camera; I mean in the computer.

It used to be that if you wanted to manipulate photographs, you needed a traditional darkroom where you had to breathe in chemicals and actually work in the dark. There was the mess you had to clean after, the waiting time for each print to see if what you were trying to do worked, and sometimes hours of preparation.

You are now officially off the hook. Instead of standing in the darkroom, you can sit at a computer and do some pretty amazing things to your photos in a twinkling. And best of all, after you

have your computer set up, you can do many of the basic things with a single software application—and even organize all your pictures to boot. This chapter shows you how.

Rev Up That Computer

You'll need something you can work on, and that means a reasonably souped-up computer. You certainly don't need to hit up NASA for a rocket science machine, as your needs will be easily met. Here's what you want (or at least what I'd want).

Elephantine Amounts of Memory

You want enough to handle not only full-size graphics files, but all the changes you will be making to them. My machine is an HP workstation with a gigabyte of RAM on it, and I'm grateful for every nibble.

Enough Hard Drive Space to Fit Delaware

You need lots—70GB to 80GB at least. Who wants to constantly shuffle CDs or DVDs of images in and out of the computer? And the operating system uses space for some of its work. Although I have over 170GB, that's probably overkill for most, but then I want the flexibility to edit video and I like to keep a spare copy of Alaska on hand.

Windows XP—for Now

Microsoft has dropped support for Windows 98, ME, and its kin. Anyway, those versions had too many problems. For all the Windows bashers out there brandishing your Macs (yes, I see you all, peering past the bite in the apple), I have few to no problems. There is that new version of Windows coming along, and I hear that it has some interesting features, but I haven't had a chance to try it out, yet.

Memory Card Reader

You need to get the photos from the camera to the computer. The Canon cameras come with cables that connect to both pieces of electronics and that transfer the images, but there are better ways of doing this.

News Flash _____

Although I refuse to get into the PC/Mac sectarian skir-
mishes, I am writing from a Windows XP-view of the work,
because that's what I currently use. However, the specialty
hardware I mention has Mac support and either the Mac
will run the Windows software or there will be native versions. No
need to feel that you have to part with a beloved friend. And, after all,
even Apple is moving to Intel chips. Oh, gee, I probably shouldn't have
brought that up, eh?

What you need is a memory card reader. You connect the reader to
your computer, take the memory card out of the computer, place the
card into the reader, and transfer the images. I'm currently using a
multiformat reader because the rest of my family uses digital cameras
that take a different type of chip. If you're going to be on vacation and
want to dump the pictures to your laptop, look for one of the traveling
models that are smaller and easier to pack.

DVD Burner

Sure you can fit a lot of images onto a CD, but I remember shooting
the bat mitzvah celebration for the daughter of old friends and using
three or four disks to hold everything. A DVD has maybe five times
the room. And if it burns DVDS, it burns CDs—a welcome backup
when you find out like I did that your friends actually *don't* have a DVD
drive in their computer.

Flat-Screen, Wide-Load Monitor

Well, perhaps a moderate-load would do—I manage with a 17-inch
monitor, though at times I can see how something larger would be use-
ful. But if you've got an old 12- or 15-inch that is doing its own impres-
sion of Lazarus, it really is time for a change.

I like flat-screen LCD because it takes up less room, the color rendition
is fine, and I like not having that curve to the screen that only started
to annoy me when it was no longer there.

Graphics Tablet

If you've never used a *graphics tablet*, prepare to be pleased. Instead of being stuck with a mouse on a pad, you have a rectangular area where you can use either a wireless mouse or a pen. You get finer control over what happens on the screen which makes doing anything a lot easier.

Photo Pro Jargon

A **graphics tablet** replaces a traditional mouse and lets you move the cursor with a mouse or a penlike implement.

Although I use the more professionally oriented Intuos3 from Wacom, I've tried the company's Graphire consumer model and found it great to use. I think this is one of those cases where the brand name actually means something, as I formerly used an off-brand tablet and didn't have the fluid control I now do.

The Security of Fort Knox

Strictly speaking, this has no direct connection to either Canon EOS cameras or digital photography. But you're not setting up a computer to do nothing but graphics editing, and you know you'll be on the Internet. I run a firewall (ZoneAlarm), anti-virus (AVG free edition because I got tired of how badly the brand name products worked), anti-spyware (CounterSpy), and a product called GreenBorder that creates safe browser sessions—just four more reasons to have all that RAM we started with.

Back-Up Storage

It's so tempting to ask, "What could possibly happen?" Let's see, where to start—oh, yeah, your hard drive could turn into so much magnetized scrap metal. You no longer have negatives to stuff into a drawer as a back-up; if the electronic versions go, so do the memories. You could copy your collection to DVDs, and that's probably a wise idea. But for convenience if something goes wrong, having an external hard drive you can plug in can make restoration a whole lot faster.

TIFF Luck

The first thing to do with new hardware or software is to go to the manufacturer's website, check the customer support section, and see what necessary or even useful updates there might be to the product. They can make all the difference between looking at an inert compilation of electronic parts and being able to do something.

Photo Printer

You take pride in your photography. You want to share your pictures with the world, and not just by email. So don't rely on the combination printer/scanner/copier/coffee brewer: get a good quality photo printer.

It's difficult to recommend one when the vendors pop out new models as regularly as promises issue forth form a politician.

Just concentrate on the features you really need. For example, do you want the ability to print images directly off the CF card without using your computer? How big a print do you want to be able to make? Do some research to see what solutions might be most cost effective.

Thumbnail Tip

I used to keep an eye on general market chatter about how permanent the prints were, but when you think about it, does it matter for most of what you're doing? Unless you're hanging something on the wall, you're really talking about something probably bound to become drawer-ware. If the colors turn on one, you can always reprint a fresh copy.

Program For Success

Digital photography without software is like a peanut butter sandwich without jelly (or a glass of milk): you can do it, but why? When you can improve the way photos look, change them at your whim, and do it all faster than you can sing all the recitatives, in Italian, from the second act of Tosca... you just have to do it.

Ah, but you have to do it with something. A PB&J without bread is nothing but a big mess on the floor. The first package you might consider is a humdinger that a colleague had recommended to me and that I've quickly integrated into my work life. It's ACDSee, a combination image cataloging, management, and editing package. Although there is a fancier pro version, you can get the consumer one for relatively short change. If for no other reason, get this software so you can keep track of your images and organize them with a minimum of psychic pain. You can get it directly from the vendor (check the resource guide in Appendix B).

After the digital homage to a heavy metal band, when you want to do trickier things to your images, it's time for Adobe Photoshop Elements. I'd call it the younger sibling of the industry standard Photoshop, but that might lead you down the wrong path. Elements may not have all the tools a pro photographer will want, but it will do virtually anything you are ever likely to want to do to your images. Sometimes it actually leads the standard version of Photoshop in newly developed features—for example, it has a full-fledged photo organizer built-in. And there are many additional programs that can add new capabilities beyond the wildest dreams of photo manipulation. I might consider it, except that I use some of the more esoteric capabilities of the full Photoshop and didn't want to duplicate all that just to organize my pictures.

Even with the "fundamental" capabilities, when you get comfortable with this family of software, you can do amazing things. I remember taking a portrait of an author friend that she was using for her new book. But part of her collar was astray. So I make a copy of the collar on the other side, flipped in, moved it over, dropped it on top of the messed up part, blended it in, and had everything looking good as new.

That said, I wouldn't rush out and get a copy just yet. First get a copy of ACDSee and ... ahem ... see how far it takes you. If you need more power, or even if you just want to become an imaging magician, you can always pick up Photoshop Elements product.

The Least You Need to Know

◆ More memory, please.

◆ Graphics tablets make mice look like a waste.

◆ Have enough computer resources to use adequate security measures.

◆ Start with just one image editing package.

Chapter 14

What You Get Is What You See

In This Chapter

- ◆ Organizing your files
- ◆ Resizing images
- ◆ Balancing exposure
- ◆ Adjusting color
- ◆ Fixing image problems

We're down to the home stretch—taking those photos and giving them that extra oomph. Guttural sounds aside, this is anything *but* grunt work. And the ideas behind it are anything but new-fangled digital.

For almost as long as there's been photography, people have been manipulating pictures. Forget about fooling others with supposed images of UFOs or inventing compromising photos. The reason people change their photographs is to improve them. Some, like

Ansel Adams, became famous in part because of their technical knowledge of how to make a picture look the way they wanted it to look.

If it was good enough for Ansel Adams, it's good enough for you. Pretty soon you'll take the images you were able to grab and heighten composition, lighting, and color. In fact, in some cases you'll actually improve things that went wrong in the taking. But first things first—install your copy of ACDSee (see Chapter 13 for how to go about configuring your computer to edit photos).

File Those Files

After you have ACDSee in place, you'll notice that it asks where you keep your photos and races off to add all of them to its database. That happens in the background, and, Holy Time Sink, should you be glad of that. It can take significant time—as in an hour or more, depending on how many images you have on your hard drive. (Then again, I had north of 9,000, so maybe you shouldn't base things on my experience.) It doesn't matter, because this is really a one-time activity. Then ACDSee will keep an eye out for new photos as they come in and add them.

Ah, but file them how? After you've pulled off dozens and hundreds of images from your Canon EOS DSLR, you'll find yourself in the virtual equivalent of having bundles of 4-inch-by-6-inch photos in a collection of albums, shoe boxes, and stacks. You wonder when you took them, where you took them, and even, sometimes, who's in them. That's why it's smart to put it all away neatly, so you can find what you're looking for.

Fancy File Names

When your pictures come into the computer using ACDSee (preferably by loading off the CF card; see the program's instructions on how to do it), you'll notice that they all end with *CRW.* As I've said earlier (in Chapter 9, as a matter of fact), digital cameras like the EOS line generate RAW files. Every camera vendor has its own version that the end of the file name, or extension, indicates.

Photo Pro Jargon

A **CRW** file extension indicates that the file is an image in the Canon RAW format.

Now look at the main part of the file names; they're all probably something like the sparkling 114_1429.CRW.

This is hardly mnemonic. In fact, take some photographs on Halloween, transfer them to your PC, keep the original names, and it's a virtual guarantee that you'll forget which witch is which. But have a heart: the poor camera doesn't know what you want and what you're photographing. Canon's answer was the necessary but still unhelpful, "Oh, just toss in numbers—they'll figure out what they want."

Good thing there's a better way. First, when I copy photos onto my PC's hard drive, I have ACDSee do it and place all images into folders that reside in the My Pictures folder on Windows XP. Then I'll look at each image in the preview and delete ones that are out of focus, so badly framed that I can't salvage something (more on that later in this chapter), and so on.

Next I use an approach suggested by Ian Macdonald-Smith (whom you may remember from Chapter 10). When I was interviewing him, he mentioned that he'd change the file names to something that made sense to him.

Call me rigid as a retentive razorback, but I hadn't considered renaming things to a convenient form. I started doing so and haven't looked back. Here's a combination that I've found useful in file names:

- Subject matter (whether Fred's Retirement, Fourth of July 2022, or Clarisse In Her Trench Coat And FBI Badge)
- Place taken (city/town and state as well as country if abroad)
- Date taken

TIFF Luck

If you put all this into the file name, it becomes … long. Very long. So long, in fact, that it spills off the end of the spaces that show filenames, making you want to say so long. I just resize the display of whatever software package I'm using because I'd rather have the slight inconvenience and know what I'm looking at. However, you might consider creating your own standard abbreviations to make things shorter while remembering what they mean.

You might have slightly different needs than I do. Some people would ask why I would bother to put the date into the name because the file has a date and I have it in a dated folder. But if I move the file, the folder doesn't help, and I might not load the photo onto the computer the day I took it. Whatever you end up picking, it should only take two or three things to bring back the context of a photo. All that typing could be another reason for keeping it short … except it doesn't have to be.

All Together Now

I know this is going to sound like hyperbole, but when I learned that I could rename a bunch of photos all at the same time with 95 percent of the work done automatically, it changed my relationship to digital photography. When you've amassed tons of images, all without regard to order, rhyme, or reason, discovering that you can take just a few minutes to rename hundreds at a time is freeing.

Look at Figure 14.1 to see how ACDSee does it. You go to the appropriate folder, select the photos you want to change, and click the Batch Rename button at the top.

Figure 14.1

Letting the computer do the typing.

You see the Batch Rename box open. We're going to keep it easy and type in the basic form of image name we'll use: Vacation_Norway, ME_8-20-2003_##. Pretty peculiar, eh? But it isn't when you know what's going on. First, I'm using underscores to separate the subject, the place, and the date. The two pound signs at the end are place keepers that the program replaces with numbers. So instead of having 1401. CRW, 1402.CRW, and so on, you get:

Vacation_Norway, ME_8-20-2003_01

Vacation_Norway, ME_8-20-2003_02

Vacation_Norway, ME_8-20-2003_03

Thumbnail Tip

Even if you think you only shoot RAW, the EOS cameras create a small JPEG, because that's what appears on the LCD screen. When you want to move the images to your computer, send all of them over. Go into ACDSee and open that folder. Click on the Sort button in the center and choose file type. It's now easy to highlight all these tiny JPEGs and delete them. That way you don't have two versions of the same image with two slightly different file names.

What's nice about this method is that, typically, all your photos from a single day are things you can group together somehow with a common theme. On the rare occasions that you have two different subjects or themes, highlight the two groups of images separately and use the appropriate subject in the bulk renaming for each.

Categorically Clicking

Having usable names is vital, but ACDSee (and Photoshop Elements, for that matter) offers the ability to attach categories to the photos as well as a rating system. Highlight a photo and you can choose the Set Categories button at the top to associate the image with whatever categories you want. Don't see the category you want? Go to the right-hand side of the application, right click on Categories, and choose New Category. To rate the photo, click Set Rating at the top.

News Flash _____

The worlds of photography and publishing have developed ways of adding information to digital image files, such as who took the picture and what the caption is. ACDSee supports this; highlight an image and press ALT-Enter. The properties database window opens and lets you add scads of information that you probably don't need to add.

When you have your images organized, you can then review them easily and decide what you need to do to them.

Size Matters

I've found that the most common thing to do with photos is resize them, one way or another. Either you'll want to make them smaller to fit onto a 4×6 standard size print, blow them up, or even crop to improve the composition. And your ability to do any of these comes down to resolution, which you might remember from Chapter 9.

When you print a picture, you're not getting the continuous image that you do on a regular photograph. Instead, the printer approximates it with a bunch of closely spaced dots. This uses the same principle of the circle of confusion that Chapter 6 discussed. The dots are so close together that they look to the unaided eye like a continuous tone. The printing term is similar to the computer term ppi, or pixels per inch. People often use dpi for ppi, leading to an entirely different type of circle of confusion.

Photo Pro Jargon _____

Enlarging is when you expand the size of an image, or a part of an image, so the resulting picture is more dramatic, or at least bigger.

When you resize an image, you must take into account what you're doing with it, because you have to adjust both the image size and resolution—and it's easiest to do resizing with a TIFF file, not a JPEG. The latter's lossy compression means that the quality will degrade, at least when you try to *enlarge* it.

That still leaves the question of what resolution to use. The answer is— that depends on how well the medium of choice can reproduce and how close to it you are. Resolution, like circles of confusion, is a matter of perception, and the closer you are, the more critical it gets because you can see more detail. The table suggests this concept in a simplified way.

Resolving the Resolution Revolution

Use	Resolution (in dpi/ppi)
Monitor viewing	96
Prints to be seen at a couple of feet	300
Prints to be seen at ten feet	60

If you don't use enough resolution, you end up with *pixilation*, in which the image looks like a collection of colored building blocks. Billboards often have a resolution of only 10–15 ppi because they're meant to be seen at such a large distance. To see what that would mean up-close, try temporarily changing the size of a photo to 4×6 at 10 dpi and view it on your monitor. Now *that's* pixilation.

Photo Pro Jargon

Pixilation is the condition of displaying an image at too low a resolution for the viewing distance, making it look like a collection of blocks.

Let's plunge into a practical example with an image from our Maine vacation (even though I don't remember your being there, but no sense in quibbling):

1. Highlight the image you want and click Edit Image at the top.

2. Click the Resize button.

3. You now have what you see in Figure 14.2.

4. Be sure that the "Preserve Aspect Ratio" box is checked.

5. Check the Actual/Print Size box and fill in the final dimensions.

Be sure to use the resolution you'll need for the minimum view-ing distance. Otherwise, you'll have to put ropes up around your home, so that people don't get too close to the walls and become disappointed with the resulting pixilation of your photography.

Figure 14.2

Make the picture fit the use—or paper size.

You can't put more detail into the picture, but you can still make pic-tures bigger. When resizing, choose Bicubic, Lanczos, or Mitchell under Resizing Filter. (Try switching off to see whether you like one enlargement more than the others.) If the results don't look as good as you like when you enlarge the image, discard the results and start over. Check the Percent box and set the increase to 110 percent, then click Done. Keep doing this until you get the size you want. For some reason this sometimes improves the enlargement.

Cream of the Crop(ping)

One reason you might want to enlarge an image is that you are going to *crop* it to improve the composition. It's like taking a print and cutting strips off the sides, top, and bottom until you get what you want. When you crop, you do make the image smaller, so you want it large enough so that the remaining part is still big enough for your needs.

Photo Pro Jargon _____

Cropping is the process of cutting out parts of an image so that you are left with only what interests you most. Good cropping can often make an average image good and a good image fabulous.

The actual cropping process is easy, as you might see in Figure 14.3. What you'll be doing is taking the lit borders and moving them around until the bright section in the center of the image contains what you want. Here are the steps:

1. Highlight the image you want and click Edit Image at the top.

2. Click the Crop button at the right.

3. Move the cursor onto any line you want to move, hold down the left mouse button, move it, and release the button.

4. When you have what you want, click Done.

Figure 14.3

Set the borders until the middle has what you want.

I usually do my cropping, then check the actual size of the image by clicking on Resize to see what the size and resolution values are. Then I'm all ready to resize if necessary to get the cropped section to the right size.

Exposure Cover-Up

If Chapter 7 made you think that exposure was something you had to get right at the start, you read it correctly. But sometimes the best candid shot will be one where exposure is off a bit. Or you might find that the scene itself had an inconvenient amount of contrast (the cad!) that the DSLR couldn't reproduce well enough.

So you're going to fix that. Lots of people look for brightness and contrast controls, but not us, because we're working on the level. Or, rather, with the *levels*, plural. When you adjust brightness and contrast, you pretty much set how one part of the image looks and base everything else on that. With levels, you can treat *highlights*, *midtones*, and *shadows* separately, giving you more control. (There is another level of control using curves, but that's trickier to use, so we're looking at this as a good compromise between being finicky and fast.) See Figure 14.4 for how this works.

> **Photo Pro Jargon**
>
> **Levels** are settings for the individual brightness of **highlights** (lightest part of the image), **midtones** (in the middle gray range), and **shadows** (the dark parts).

Choose how you want the highlights, midtones, and shadows to appear. Notice the line that crosses the histogram (look back at Chapter 7). As you change the levels, the curve will start to move, showing the changes in how brightness responds in different parts of the image:

1. Highlight the image and click Edit Image.

2. Click the Exposure button.

3. Click the Levels tab.

4. Be sure that Channel is set to Luminance.

5. Move the shadow, midtone, and highlight triangles until you get the look that you want.

Another trick worth knowing is using the tiny Exposure Warning button just to the left of the Auto button. Move the cursor over it, the left mouse button, and as you change the levels, it will show if you run the danger of having shadows disappear into black or highlights turning into undistinguished white patches. The endangered highlight areas will turn red; the shadows at risk turn green.

Figure 14.4

Change the levels to get the balance of lighting that you want.

TechnicalColor

On top of changing exposure, you can change the balance of color— sort of like changing a balance of power, but with immediate nonviolent gratification, including ...

◆ Improving critical color balances, such as skin tone

◆ Emphasizing parts of the image by subtly underscoring a visual contrast through color (think back to Chapter 5)

◆ Changing the mood of a scene by making it cooler or warmer

Again you'll start with highlighting an image and clicking Edit Image. There is a Color button, and you could just go in there and shift around the red, green, and blue levels (and do play around with it).

But let's be a bit contrary and go back to Levels in the Exposure tool, because by using individual color levels, you can get the same increased control as you do when setting exposure levels. Here's how ...

1. In the Channel box, select the color you want to adjust.

2. Change the shadow, midtone, and highlight buttons.

3. Go to another color channel, if you want, and do the same thing.

4. When you're done with all the level changes, click Done.

You'll see a histogram, which may differ from the overall luminance one, for each color channel. Getting what you want might require going back and forth a bit. Check the insert section to see what a difference color balance can make with this same image of woods in Maine that you're probably sick of looking at in black and white.

Problem Fixing

So far the emphasis has been on making aesthetic tweaks. But there are also some out and out problems you can repair pretty easily. Here are some of the best to know:

News Flash _____

Actually, if you have Photoshop Elements, you already have a magic wand—one of the editing tools that lets you specify parts of an image that have same color.

- ◆ Red eye

- ◆ Removing noise

- ◆ Adding sharpness

- ◆ Changing perspective

All are as easy to do as everything else. You should be feeling like an imaging wizard already, though you'll have to get your own magic wand.

Red Eye

When you have the image up for editing, click the Red Eye Reduction button. Choose the eye color from the drop-down box and slide the bar left and right until you get the amount of correction you want.

Removing Noise

Noise—small irritating specks—becomes a problem when you have to correct for a strong underexposure or you are using an ISO speed of 800 or more. So get the image into the editor and click the Remove Noise button. Try the different types to see which work best, because you can lose a little sharpness in the process.

Adding Sharpness

Unsharp masking is an old film trick in which the darkroom worker, through a series of steps, creates a copy that is a negative of the original—dark where the original is light, and vice versa. The copy is pretty thin. When you sandwich the two together, you get slight halos around all edges. That makes the edges appear to stand out more, creating the illusion of greater sharpness. (Just check in Chapter 6 about when things are most in focus.)

Photo Pro Jargon

Unsharp masking is a way of digitally creating halos around edges that create apparent extra contrast that, in turn, makes the image seem sharper.

You can do the same thing digitally with a tool, found in virtually all decent image editors, called unsharp mask. By adjusting three settings, you control the degree of apparent sharpening to get improvement without going so far as to make your image seem angelic by adding a glow around everything.

The three settings are …

- ◆ Amount—how much change in the light at the edges will happen, with higher values making the edges darker

- Radius—the width of the halos, with higher values making bigger halos

- Threshold—how much brighter one pixel has to be than another next to it before the sharpening kicks in there, with higher levels requiring greater difference

Set the displayed size to 100% and bring the image into the editor by clicking the Edit Image button. There are different schools of thought of how to apply unsharp masking. Here's one that should work:

1. Start with the radius. If there's lots of fine detail in your image, try a 0.5 value. For a normal image, go with 1.0 to 1.5. Images with little detail might require higher values, like 2.0 to 4.0.

2. When you have the radius, set Amount. Slide it back and forth until the halos become obvious, then slowly move it back until they enhance the edges but don't call attention to themselves.

 Thumbnail Tip

Unsharp masking should be absolutely the last thing you do to your image. Otherwise, you actually run the chance of increasing noise and other problems in your image, making it worse instead of better.

3. Slide Threshold back and forth until little specks start to appear in the image where there are no edges. Then back it off until those specks just disappear.

This won't save an out of focus image, but you can add a lot of punch to photos that are already good.

Getting Some Perspective

Chapter 5 discussed some of the problems of getting the right perspective in a photo. Among the amazing things image editing software can do is to reshape and stretch a picture to correct distortions in perspective. Unfortunately, the regular version of ACDSee doesn't have the feature.

To change how the perspective of a picture looks, you'll at least need either ACDSee Pro or Adobe Photoshop Elements. I won't go into too much detail, but once you have the right application, the steps are roughly the same:

1. Open the image in question in the application.

2. Select the entire image, so the operation works on all of the picture.

3. Choose the perspective correction function, which will put little boxes or handles on the corners and edges of the images.

4. Drag the boxes or handles to your heart's content and stretch it into the shape you want.

There's no such thing as a free lunch, and if you stretch the image too far, you'll start degrading it in other ways. But when you're stuck, perspective correction is great to have handy.

The Least You Need to Know

◆ Organize your files before you do anything else.

◆ Adjust size, exposure, and color balance to make images look their best.

◆ Fix problems that made it that far.

◆ Sharpening your photo is the very last step that you should take.

Chapter 15

Image Explorer

In This Chapter

- ◆ Use layers
- ◆ Select parts of photos
- ◆ Combine photographs
- ◆ Retouch an image
- ◆ Add text
- ◆ Burn and dodge

After good composition and exposure and computer editing to tweak light and color balance, there's actually more you can do to (or with) your digital photos. You can restrict image corrections to a specific part of a picture, take elements from one picture and put them into another, stitch together landscape shots for a panoramic view, take people and put them in new backgrounds, use ready-made backgrounds for portraits, or even add specialty lighting equipment to create your own studio.

You don't need to use any of these techniques to get good shots, but some will help you take that next step and perhaps get something that might otherwise be impossible. To use them,

however, you'll need to get a copy of an editing program such as Adobe Photoshop Elements or Corel PHOTO-PAINT to get the features you'll need. While I'll use Photoshop Elements for the examples, there are equivalent tools and concepts in any good image editing program.

The Layered Look

Before we go into any technique, let's look at an important editing concept: *layers*. Instead of making changes directly on the image itself, you can add things, subtract parts, select an area, or make adjustments on the layer and apply them to the image without changing the image itself.

Photo Pro Jargon _____

A **layer** is a work area that sits on top of the image and lets you make changes to the image without changing it.

The terminology may change from one program to the other; for example, Photoshop Elements refers to the layers as just that, layers, although PHOTO-PAINT uses the term "lenses" for layers that correct color or tone and "object" for layers that hold parts of an image. Figure 15.1 shows an example of a photo you've seen in Chapter 5 with an extra layer in Photoshop Elements.

Figure 15.1

A photo with an example layer sitting on top of it.

You might notice a couple of things. First, the photo has a .PSD file extension. Don't check back—it's not one of the regular image file types. Instead, this indicates that we've saved the image as a Photoshop file. Remember how I said that you'll want to save all your images as RAW? That's true for the unedited ones. When you really start to edit, though, it's handy to keep a PSD copy with all the changes, and then to save TIFFs or JPEGs as you need them.

Next, at the right of the screen there's a little copy of the entire picture labeled Background. Just above is a blank box called Example of a Layer. Because there's nothing in the layer, you can see no obvious change in the image.

That's because we haven't put anything into the layer, so let's fix that. Using the text tool (the capital T on the toolbar to the left of the image), I insert a sentence, shift it around to where I want, and then decide on a font size. Now you see a capital T in the box called Example of a Layer in Figure 15.2.

Figure 15.2

The new layer now has text in it.

I could right-click on the layer and delete it, removing the text, or I could even click the little eye next to the new layer and temporarily remove it from sight, should I want to see how things look without it.

If you're like me, this was sent by the digital imaging deities, because even if you make a mistake, you can always toss the layer and start over without affecting the original image. By using layers, you can also keep better track of exactly how you're changing the picture. Unlike using

undo, you can reverse or modify any change you made without having to first get rid of every other change since.

Photo Pro Jargon

Image editors will also typically have an **undo** function to step back and reverse what you have done. In Photoshop Elements, typing CTRL-Z does it.

By using layers, you can also build up changes and adjustments to the image one bit at a time and not lose track of them. In fact, let's make it an imperative: any time you edit an image, make all changes on additional layers, not on the image itself. That way, should you tire of the change, you'll be able to go back to the original.

There are different types of layers, as well. Now I'll use an adjustment layer, which lets me change an overall quality of the image. In this case, I go to the Layer menu at the top and add a Levels layer, as in Figure 15.3.

Figure 15.3

Change levels in a layer.

This is the same type of image quality adjustment we made in Chapter 14, but now we do it in a safer way through a layer. The photographer/author in me wants to call this a powerful tool in photo manipulation, but the techie/kid just says that it's incredibly cool. Either way I'm right.

There's far too much about layers for me to cover, but we'll look at one more capability, for now. It's called *opacity*.

A layer doesn't have to be an all or nothing experience. Using opacity you can dial in the degree to which you want the layer to affect the image. As you'll see in Figure 15.4, I've added a new layer—a color fill—and chosen red to lay down a solid color over the image. Now you can't see anything but that—well, anything but a gray, since this image appears in black and white in the book.

Photo Pro Jargon

Opacity is the degree of transparency a layer can have.

Figure 15.4

We've covered the entire image with red.

However, if I first click on the Color Fill 1 layer (if it's not already highlighted) and then click the drop-box next to Opacity, I can choose the degree to which the results of the layer show up in the image. At 100 percent, you see all of it. But if I change that to 20 percent, Figure 15.5 shows the result.

Although harder to see in black and white, in color you'd notice a very warm look to the image. Opacity works with virtually anything in a layer, even level changes.

Figure 15.5

By lowering the fill's opacity, we warm up the whole image.

Pick and Choose

Up until now, everything we've done in editing photos has been to the entire image. But you don't need to stop there. Editing programs actually give you the ability to select only parts of the image and do an amazing collection of things, including the following:

◆ Balance the exposure or adjust color

◆ Increase the sharpening or intentionally blur

◆ Copy part of a photo to place over another part

◆ Combine parts of different photos

With the power to affect any part of an image you want, you can create photos that are exactly what you envisioned. There is a whole list of ways you can select a part of a photo:

◆ Define a rectangular or elliptical *marquee.*

◆ Draw a polygon around an area.

◆ Mark a free-form boundary called a *lasso.*

◆ Follow an edge or boundary in the image with a *magnetic lasso.*

◆ Select an area of a given color with the *magic wand.*

◆ Paint or draw over what you want to select with the *magic selection tool*

Photo Pro Jargon

Marquees are shapes that select any part of the image that fall within them; they are either rectangles or ellipses. A **lasso** is a tool that lets you select any area of an image by drawing a freeform line around it. A **magnetic lasso** will look for the nearest edges in the image and pull the lasso line to them. By clicking on a point of the image, the **magic wand** selects all the surrounding area with the same color. Draw or paint over what you want to select with the **magic selection tool** and let the computer automatically select it.

Figure 15.6 shows an example of selecting an area using a rectangular marquee.

Figure 15.6

Using a rectangular marquee to make a selection.

Look at the top of the screen and let your eye move straight down from the Level menu. Just below the horizontal toolbar you'll see some rectangles. They let you control how multiple selections interact. The choices, looking from left to right, do the following:

◆ The new selection replaces the previous one.

◆ The new selection gets added to the previous one, with the selected part being a combination (even if the two individual selections don't touch).

◆ The second selection deselects wherever it overlaps with the first.

◆ The selected area is where the two individual selections overlap.

By thinking about how different selection tools would interact, you can carve out any part of an image you like. Here's a quick example of using layers combined with selection to do things to an image that would be otherwise impossible. In Figure 15.7, I've taken the following steps:

1. I created a layer that duplicated the picture—actually called Duplicate Layer on the Layer menu.

2. Using a combination of the magic wand and rectangular marquees and adding everything to the selection, I chose most of the faded part of the jacket collar.

3. On the Select menu, I chose Inverse to choose everything in the layer (remember, a copy of the image) and then deleted all that using the Delete Selection choice on the Select menu.

4. Once again I chose Inverse to get back to the collar parts that I originally selected, and that were the only parts of the copied image remaining.

5. I now used levels on the entire layer to make the light parts of the collar much darker.

6. Finally, using the Select menu, I picked Deselect.

Figure 15.7

Use selection to change only part of an image.

Because the layer was a copy of the image sitting directly above it, I effectively changed the levels on that one part of the collar. In this case it added nothing to the image, but I've used this in the past to bring out details in one part of a picture while leaving the rest as it was.

Thumbnail Tip _____

When you make a selection, you can also choose a number of pixels of feathering. This creates an edge that many pixels wide around the entire selection that is fuzzy. When you now move that selection elsewhere, or even copy it to another picture, it blends into the background more convincingly. Once I took a portrait where one part of the subject's collar was in disarray. So I copied, with feathering, the other part of the collar, flipped it, and dropped it onto the problem area, effectively building a new collar.

All Together Now

With what you've just learned, you can start taking elements from one photograph and adding them to another. Here are the steps:

1. Open both photographs and resize them so that they have the same resolution as each other and so they are in the proper size relationship. For an example, I'm picking a photo of the Marsh-Billings-Rockefeller National Park from Chapter 11 and a shot of two jousters from Chapter 12.

2. Click on the photograph with the element that you want to take. Select the element using the selection tools, remembering to feather the edges so that it blends in better. (You can experiment with different amounts of feathering to see what works best.)

3. Use Copy from the Edit menu to make a copy of the selection.

4. Click on the other photograph and save it as a PSD image, then create a new layer.

5. Make sure that you have the new layer highlighted and then paste the selection into that layer.

6. Using the Move tool (the arrow and plus sign on the left hand toolbar), move the element into place to create your own reality.

If you want, you can use Merge Layers from the Layer menu to create a single layer when you have everything the way you want. Remember to save the image under a new name so that you don't accidentally write over one of your originals.

Figure 15.8

Use selection to change only part of an image.

TIFF Luck

Although combining photos can be fun, getting them to look like one image rather than two pasted together can be tricky. The biggest giveaway is lighting. Choose two photos where the light comes from the same direction in both.

Touchy, Retouchy

There will be times that you find problems in a picture. Perhaps a person whose portrait you took has an unsightly blemish. Maybe a landscape is marred by a power line crossing the foreground.

Photo Pro Jargon

The **clone stamp tool** makes a copy of whatever in a given distance and direction you specified and places it where you have the cursor. The **healing brush tool** is like the clone stamp except that it also matches color, texture, and lighting to better match someone's complexion.

It doesn't matter, because you can fix such problems with retouching. Doing this in film-based photography is difficult at best, but it's a snap in digital. There are three basic approaches to use:

◆ Select another area, copy it, and place it over the offending part.

◆ Use the *clone stamp tool.*

◆ Use the *healing brush tool.*

You've seen how to select an area and copy it, and the first method of retouching is essentially that. You might look for a patch of lawn to copy and move to a brown spot to improve a picture you take of a house, or possibly remove a sign from the side of a building.

For smaller changes in an image, the clone stamp or healing brush are better choices (and the clone stamp, at least, has equivalents in many other editing programs). Here are the steps for using the healing brush to remove a freckle from a picture of someone's face:

1. Open an image in Photoshop Elements.

2. Click on the clone tool.

3. Move the cursor over a nearby part of the face without a freckle, hold down the Alt key, left click, and release the Alt key.

4. Now move the cursor back over the freckle and left click without the Alt key.

TIFF Luck

As you fix the image, you'll see a mark separate from the cursor that will show the source for the replacement section. Keep an eye on it, because if you're not careful, as you move around it might drift into a part that looks completely different, making the picture look messier than it did in the first place.

What you've done is set up a relationship. Every time you click on the image, you copy what's on the spot that is the same distance and same direction away as the first spot was from the second. You can also change the size of the healing brush to vary the size of the spot you need to fix.

Dot the I

When explaining layers, I showed one with text. It's simple to add writing to make titled photos, greeting cards, or anything else. To put on your type, click the text tool (the capital T, if you'll remember) and then click where you'd like on the photo. Photoshop Elements will automatically create a text layer. You can choose the font style and size as you would with any computer application.

There are a few more things you can do, as well, including warping text. Figure 15.9 shows a text layer added to a photo from Chapter 12.

Figure 15.9

Here's the text that will eventually warp.

With the Text tool still selected, notice that on the right hand end of the text tool bar (where you select the font size, among other things), there is an icon that looks like a slanted T sitting atop a curved line. Click that and a dialog box called Warp Text appears. Now select Arc Upper for Style and the text actually changes shape as you can see in Figure 15.10.

Figure 15.10

Now we've warped the text.

We could adjust the bend percentage or the horizontal or vertical distortion to change how the text looks, but we won't this time. Instead, we use the Move tool, click the text, and move the cursor to a corner of the text box. The cursor turns into a curved arrow, letting us freely rotate the text—in this case to match the slant of the hoop—and then to move it to the final position in Figure 15.11.

Figure 15.11

The text in its final position.

The Dark Side

Two classic types of photo manipulations are *burning in* and *dodging* to control how light or dark a specific area of an image is. With film, this was done when making a print. To burn in you'd block all the light from reaching the print except when you wanted things darker. To dodge a spot, you'd block the light only there.

It's easy to do this digitally. There are Burn and Dodge tools at the very bottom, alternating with the Sponge tool (which lets you increase or decrease color saturation). But there's a problem because you have to use them directly on the image and not on a layer.

Photo Pro Jargon

Burning in a part of an image means to increase exposure to darken it classic types of photo manipulations. **Dodging** means decreasing exposure to lighten it.

If you don't mind working on the image itself, that's fine. However, there's a neat trick you can use to duplicate the effect while still using a layer:

Thumbnail Tip

Any time you see a little arrow in the lower right-hand corner of a tool, try putting the cursor on the tool and holding down the left button on the mouse. You'll see a choice of tools suddenly appear.

1. Create a new layer.

2. Click on the Brush tool (five spots up on the toolbar from Dodge and Burn).

3. Set the size of the brush to cover the area you want to change and choose a brush with blurred edges. Change the brush opacity to something low, like 15 percent. (I actually used 30 percent to make the change easier to spot.)

4. Be sure that the foreground and background colors are set to black and white respectively. You find them in the two squares all the way at the bottom of the left-hand toolbar. If they are set to anything else, click on the tiny pair of black and white squares to reset them.

5. Brush over the area you want to darken.

Figure 15.12

The right side of the boy's face is now darker.

As you can see in Figure 15.12, I burned in the right-hand side of the boy's face. By clicking the little curved arrow next to the foreground and background color squares, I can switch the brush to white and, lowering the opacity, brush the shirt to lighten it, as in Figure 15.13.

Figure 15.13

After dodging the shirt.

Everything you've seen in this chapter is just the beginning of advanced editing. For example, Photoshop Elements has a merge capability (as can be found in other software packages as well) that can take a series of pictures and turn them into a single panoramic view. You can create slide shows to show off your work, or even create professional-style photo books.

Although I doubt you're reading this book from one cover to the end, if you've made it to here (heck, even if you started here), I wish you good luck and a lot of enjoyment making great images with your Canon EOS equipment. And feel free to e-mail a link (not the actual pictures) to a website with your images; I'd love to see how things worked out. You can reach me at erikbsherman@gmail.com.

The Least You Need to Know

- Use layers to control and track your photo edits.
- Create selections to work exactly where you want to in an image.

- Combine and retouch photos for new effects.

- Sharpening your photo is the very last step that you should take.

- Add text to have your images say more.

- Burn and dodge to selectively lighten and darken parts of a photo.

Appendix A

Glossary

Adobe RGB Often called Adobe RGB 98, it's the native color space of Adobe Photoshop and is popular with many professional printers.

AF Point One of the rectangles you see in the viewfinder. Each one can be the place where the camera's auto focus looks to focus the image. You can select a particular AF Point, or the camera can do it for you.

ambient lighting Whatever lighting already illuminates a scene.

aperture The f-stop setting of the lens, which means how wide the lens iris is open and how much light can get in.

auto focus When the camera focuses the lens for you.

ball head A device that sits atop a tripod or monopod and holds the camera, letting you position it to the angle you want. The ball head moves freely in any direction and has a single control to lock it into place; a second control handles rotation.

bouncing A technique of pointing a flash unit somewhere other than the subject—like a ceiling or wall—and using the reflected, more diffuse light.

bracketing Taking a few shots, some with greater exposure and some with less, in the hopes that at times an honest mistake will pull things through when knowledge and experience do diddly.

burning in Making part of an image darker.

center-weighted average metering The camera calculates exposure, counting the center most but also averaging in readings from elsewhere in the viewfinder.

CF (compact flash) card A type of storage that you put into the camera to keep your pictures until you move them to your computer.

clone stamp tool Makes a copy of whatever in a given distance and direction you specified and places it where you have the cursor.

color space: The collection of colors that something—whether a human eye or some kind of electronic device—can see.

color temperature The color cast of visible light, expressed in degrees of Kelvin.

composition The art of arranging visual elements to create an intended effect.

cropping The process of cutting out parts of an image so that you are left with only what interests you most. Good cropping can often make an average image good and a good image fabulous.

cross screen filters Cause bright objects or lights to seem as though they emit distinct rays or lines of light.

CRW A file extension indicating that the file is an image in the Canon RAW format.

depth of field The range of distances within which objects in a picture look sharp.

depth of field scale Shows the depth of field of a lens.

diffuse light Light scattered from the source, creating blurry-edged shadows.

Digital Signal Processor A computer chip that manipulates information, like an image file.

dodging Making part of an image lighter.

dpi Printing term expressing the resolution of an image in dots per inch.

drive mode The EOS feature that lets you go from single images to continuous shots so long as you keep the shutter button pressed.

DSLR An SLR that uses digital technology to capture the image.

dynamic range *See* latitude.

EF Canon lenses that work with the company's digital DSLRs as well as with the older film SLRs.

EF-S Canon lenses designed specifically for the company's digital cameras.

enlarging When you expand the size of an image, or a part of an image, so the resulting picture is more dramatic, or at least bigger.

environmental portraiture Where the surroundings a person is typically in are an important element of the image.

evaluative metering The camera takes separate readings over parts of the entire image.

f-stop A shorthand for specifying and setting the amount of light a lens can let in; the smaller the f-stop, the more light.

fill lighting Additional light intended to fill in shadows in a scene.

filter A specially treated or tinted piece of glass that you screw onto the end of your lens to get a particular optical effect.

fixed focal length lens One with only a single focal length.

flash A type of strobe light that pumps out brief bursts of light about equivalent in color temperature to a cloudy day.

focal length Distance from the lens to where its image forms when the object being viewed is in focus when at "infinity"—which, for all practical purposes, means a stone's throw away.

focusing ring The part of the lens you turn back and forth to focus the image.

golden hour Time about an hour after sunrise or before sunset when the sun offers a warm and flattering light.

graduated filters Have a color that changes in hue from one side to the other, at which point the filter becomes clear.

graphics tablet Replaces a traditional mouse and lets you move the cursor with a mouse or a penlike implement.

hard light Light that is strongly directional and casts sharp-edged shadows.

healing brush tool Like the clone stamp except that it also matches color, texture, and lighting to better match someone's complexion.

highlights The lightest part of an image.

hyperfocal distance The closest distance at which everything between it and infinity will seem in focus.

in focus When, in an image, adjacent regions of colors or shades of the same color are as distinct as possible.

ISO setting Determines how readily the sensor responds to light striking it.

JPEG Developed by the Joint Photographic Experts Group (hence the name) stores an image with lossy compression.

key light Provides the bulk of the illumination in a scene.

lasso A tool that lets you select any area of an image by drawing a free-form line around it.

latency The time lag between when you press the shutter button and the shutter opens.

latitude The range in light intensity that a medium can recognize. In the world of digital sensors, the more technical term is dynamic range, but it works out to about the same thing as far as we non-purists are concerned, so we'll use the traditional photographic term. Call it a latitude attitude.

layer A work area in a photo editing application that sits on top of the image and lets you make changes to the image without changing it.

leading lines The naturally occuring visual lines in a scene that you use to point to your subject.

lens cleaning fluid A chemical solution for cleaning residue from a lens.

lens elements The pieces of glass that provide that optical *je ne sais quoi*.

lens shade (hood) Attaches to the front of a lens to help reduce glare and even flare when you're shooting toward a light source.

lens speed The largest amount of light the lens can let in; it's the same as the lens's lowest f-stop.

lens tissue A thin, soft paper designed to clean lenses.

levels Individual brightness settings for an image's highlights, mid-tones, and shadows.

light meter A device that measures light and indicates how to properly expose an image.

lossy compression A type of data compression that reduces the amount of storage needed for information by elimiating less important data.

magic selection tool Lets you draw or paint over what you want to select in an image and then leaves it to the computer to do the real work.

magic wand A tool that selects all the surrounding area with the same color.

macro lens One that focuses at short distances from the subject.

main light *See* key light.

magnetic lasso A tool that looks for the nearest edges in the image and pulls a lasso line to them.

manual focus You focus the lens instead of letting the camera do it.

marquees Shapes that select any part of the image that falls within them.

maximum burst The largest number of photos the camera can take before it has to wait until it has written images out of its built-in memory and onto the compact flash (CF) card you put in.

metering mode The type of automatic exposure metering you tell the camera to do.

microfiber cloth A small piece of cloth, used for cleaning lenses, that has tiny fibers that can absorb oil and dirt without scratching the glass.

midtones The tones in an image that are in between the highlights and shadows.

monopod A single column used to help steady a camera.

multiple image filter Turns an image into multiple copies of the same scene.

negative space The blank areas of an image.

neutral density (ND) filter Cuts down the light getting into the lens.

noise The small unintentional interfering signals that appear in any electronic device.

normal lens More or less reproduces the world the way your eyes see things.

opacity The degree of transparency a layer can have.

pan/tilt head A device that sits atop a tripod or monopod and holds the camera, letting you position it to the angle you want. It has three controls—one for forward and back, one for side to side, and one for rotation.

panning When you move your camera to follow your subject so you capture it while blurring the background.

partial metering The camera calculates exposure based on what's in the very center of the image.

pixelation The condition of displaying an image at too low a resolution for the viewing distance, making it look like a collection of blocks.

polarizer A filter that acts like a good pair of sunglasses to reduce glare and make some objects, blue skies in particular, more dramatic.

pops When an element of the picture is vibrant enough to stand out and grab the notice of the viewer. Often said about bright colors.

ppi A computer term expressing the resolution of an image on a monitor in pixels per inch.

prosumer A line of cameras with more capabilities than a consumer model, but still shy of the features (and price) of a pro camera.

RAW A proprietary image file format used by a DSLR.

resolution A measure of how much detail you can see in an image.

RGB A way of representing colors as a mix of red, green, and blue. Personal computers represent all colors with an appropriate mix of these three colors.

rule of thirds If you divide what you see in the viewfinder into three parts, having imporant elements in the left or right or upper or lower third is aesthetically satisfying composition.

selective focus A composition technique in which you direct attention to the subject of your photograph by having it be the sole object in focus.

shadows The darkest parts of an image.

shutter speed How long the camera opens the shutter to expose the sensor to light from the lens.

skylight filter A filter with a slight pink color that helps cut haze and reduce a bluish tinge to outdoor light.

SLR A single lens reflex is a type of camera where what you see in the viewfinder is what the camera will record. A moving mirror reflects what comes through the lens up toward your eye. When you push the shutter button, the mirror swings up before the shutter opens.

soft Means a bit out of focus. A picture can be more soft or less soft and it can be the result of a mistake (most cases) or intentional (when I do it and need an excuse). If it's really out of focus, there are a few other technical terms: blurry, fuzzy, or "What the *heck* am I looking at?"

spot meter A light meter that lets you aim through a viewfinder to take a reading on a small portion of the scene in front of you.

sRGB Stands for standard RGB, a color space used widely in personal computers.

step-down ring Adapts a filter to a lens whose frong is smaller than the filter.

step-up ring Adapts a filter to a lens whose front is bigger than the filter.

stop A change to the metered exposure equivalent to a full f-stop or shutter speed.

telephoto converter A specialty lens that multiplies the focal length of a telephoto lens, usually by 1.4 or 2 times.

telephoto lens Makes subjects look larger and nearer.

threshold level An engineering or scientific term meaning that a certain amount of something or other has to happen before you get a result. In the case of a digital camera's sensor, there has to be enough light to get it to react and generate the electricity that translates into the image.

TIFF Short for tagged image file format; an industry standard file format that stores all the information of an image.

tripod A three-legged device that acts like a stand to steadily hold a cameras.

undo An editing function to step back and reverse what you have done.

unsharp masking A way of digitally creating halos around edges that create apparent extra contrast that, in turn, makes the image seem sharper.

UV filter Removes some of the ultraviolet radiation found in sunlight, improving contrast and reducing atmospheric haze.

visual focus The part of a photograph that draws the viewer's eye.

visual weight Parts of an image have an emphasis; ideally they should be balanced so the picture doesn't seem lobsided.

white balance An adjustment that lets the camera compensate for the color cast of light so that whites are really white.

wide-angle lens A lens that takes in a wide angle and ends up making the subjects look small and far away.

zoom lens Lets you choose from a range of focal lengths with a ring that changes the focal length as you twist it.

Appendix B

Resources

This appendix includes a collection of vendors, products, and retailers that I've personally found worth knowing. I hope they help enhance your photography experience as much as they've helped mine.

Resellers

It can be tough to find places that are trustworthy for buying equipment or supplies. I have shopped these professional photo retailers either in person or over the phone and Internet and have found them to have extensive product lines, significant practical knowledge, and, on the relatively rare occasions they make mistakes, the readiness to make things right. Although they largely do cater to professionals, they are happy to work with those who just have an interest in photography:

- ◆ Adorama—www.adorama.com
- ◆ B&H Photo—www.bhphotovideo.com
- ◆ Calumet—www.calumet.com
- ◆ E.P. Levine—www.cameras.com
- ◆ Hunt's Photo & Video—www.huntsphotoandvideo.com

Equipment and Accessories

The following sections list websites for the vendors I've mentioned and a few that weren't mentioned.

Cameras, Lenses, and Hardware

◆ Canon—www.canon.com—a great source of information on Canon EOS products, naturally.

◆ Sigma—www.sigma-photo.com—a leading third-party supplier of EOS-compatible lenses.

◆ Tamron—www.tamron.com—another leading third-party supplier of EOS-compatible lenses.

◆ Wacom—www.wacom.com—top-notch graphics tablets.

Cases

◆ Case Logic—www.caselogic.com—makers of cushioned soft-sided camera cases, among other things.

◆ Domke—www.tiffen.com—another well-regarded bag manufacturer. Owned by Tiffen.

◆ Lowepro—www.lowepro.com—my favorite camera bag company.

◆ Tamrac—www.tamrac.com—a leading supplier of camera bags.

Filters

◆ B+W—www.bwfilter.com—one of the top filter makers on the market.

◆ Cokin—www.cokin.com—makers of a system of resin filters that affix to the front of a camera lens. They have some unusual and interesting special effects filters.

◆ Heliopan—www.heliopan.com—another top filter maker.

◆ Lee Filters USA—www.leefiltersusa.com—like Cokin, also makes a system of resin filters that affix to the front of a camera lens with extensive special effects choices.

◆ Tiffen—www.tiffen.com—a more moderately priced vendor of filters and other things photographic.

Lens Cleaning

◆ Photographic Solutions—www.photosol.com—top-notch suppies for cleaning lenses.

Software

◆ ACD Systems—www.acdsee.com—makers of ACDSee.

◆ Adobe Systems—www.adobe.com—makers of Photoshop.

Storage

◆ Lexar—www.lexar.com—card readers, USB flash drives, memory card readers, and other things, including software to rescue images from memory cards.

◆ SanDisk—www.sandisk.com—another major manufacturer of memory cards and USB drives.

Tripods and Supports

◆ Manfrotto—www.manfrotto.com—top camera supports for top pros.

◆ Tiffen—www.tiffen.com—makes more moderately priced tripods.

Index

G

H

M

N

O